tangled up!

Walter Foster

Quarto Knows

Quarto is the authority on a wide range of topics.
Quarto educates, entertains, and enriches the lives of our readers—
enthusiasts and lovers of hands-on living.
www.quartoknows.com

Walter Foster

6 Orchard Road, Suite 100
Lake Forest, CA 92630
quartoknows.com
Visit our blogs @quartoknows.com

Printed in China
5 7 9 10 8 6 4

tangled up!

More than **40** creative
prompts, patterns, and projects
for the tangler in you

by Penny Raile

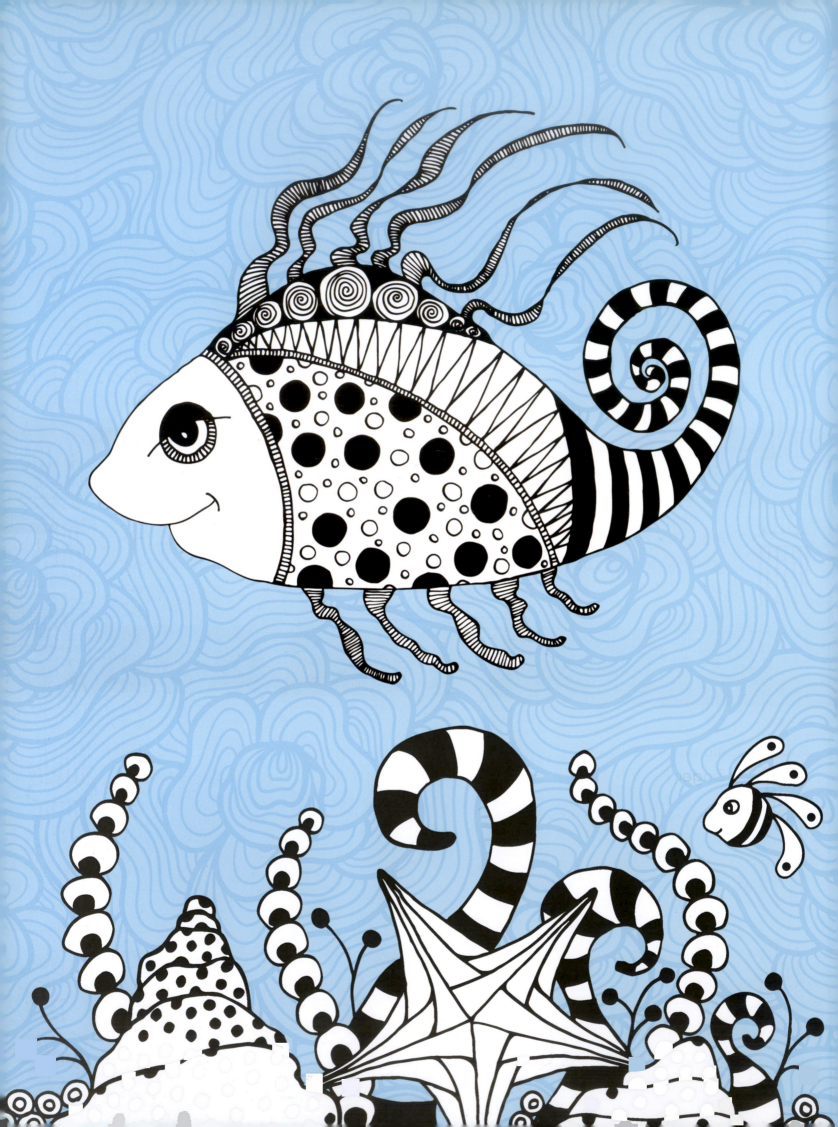

Table of contents

Introduction to Tangling

Tangling is a fun, meditative art form that uses simple patterns to create unique and beautiful pieces of art. Through the use of repetitive patterns, anyone can create artwork that looks complex but is easy and simple to produce. The beauty of tangling is its whimsical yet structured quality—the key is to focus on drawing each line or stroke without worrying about the end result. Don't worry if you've never drawn before; tangling is fun and easy—anyone can do it!

How to use this book

Welcome to the fun, imaginative world of tangling! Whether you've drawn before or are picking up a pencil for the first time, you're sure to find fun and inspiration in the pages of this interactive book. From learning to create basic tangles and patterns to making your own personalized alphabet and illuminated letters, this book is sure to get your creative juices flowing.

After learning about a few basic tools and materials, you'll be invited to try your hand at some basic patterns, tangles, and step-by-step projects. There are also templates at the end of the book for you to copy and scan, so you can tangle over and over again. Indulge your imaginative side by learning to create tangled flowers, monsters, and critters; letters and numbers; and cute embellishments you can add to anything for a personal touch. There are no mistakes in tangling, so let loose, have fun, and tangle away!

Tools & Materials

All you really need to tangle is paper, a pen, and a pencil; however, there are a few additional materials you may want to have handy as you begin your tangling adventure.

Sketch Pads and Drawing Paper
Sketch pads come in many sizes and are great for tangling on the go. There are a variety of quality drawing papers to choose from. Visit your local art supply store to see which type you prefer.

Smooth and Vellum Bristol Board
Both of these Bristol board types work well for tangling. Experiment to see which works best for you.

Hot-pressed Watercolor Paper
This paper's untextured surface lends itself well to illustration and small details.

Pencils
In tangling, pencils are used to draw strings, create borders, and add shading. Pencils are designated by hardness and softness. H pencils are hard and make lighter marks; B pencils are soft and make darker marks. Pencils range from very soft (9B) to very hard (9H). You can also use standard No. 2 and No. 4 pencils.

Blending Stumps
Blending stumps allow you to blend or soften lines and areas in your tangles.

Sharpener
You can achieve various effects depending on the sharpness of your pencil, but generally you'll want to keep your pencil well sharpened.

Erasers

One cardinal "rule" of tangling is that there are no mistakes, making erasers unnecessary; however, when creating some types of art, you may want to erase old sketch lines as a means of cleaning up your final artwork. Kneaded erasers can be shaped into a fine point or used over broad surfaces. They leave no dust and are great for lifting out highlights. Vinyl erasers are great for removing graphite without chewing up the paper.

Archival Ink Pens

Tanglers typically use archival ink pens to render their finished artwork. It's helpful to have a selection of pens in every point size. Take time to familiarize yourself with these pens before getting started. Pens are typically numbered as follows:

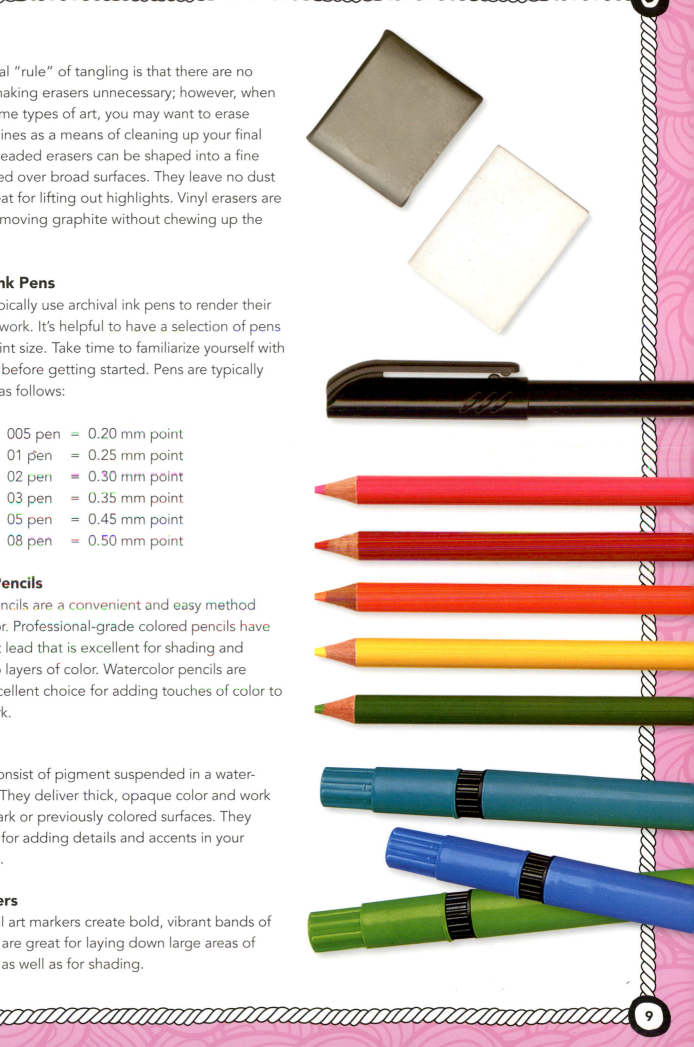

005 pen	=	0.20 mm point
01 pen	=	0.25 mm point
02 pen	=	0.30 mm point
03 pen	=	0.35 mm point
05 pen	=	0.45 mm point
08 pen	=	0.50 mm point

Colored Pencils

Colored pencils are a convenient and easy method to add color. Professional-grade colored pencils have a waxy, soft lead that is excellent for shading and building up layers of color. Watercolor pencils are another excellent choice for adding touches of color to your artwork.

Gel Pens

Gel pens consist of pigment suspended in a water-based gel. They deliver thick, opaque color and work easily on dark or previously colored surfaces. They are perfect for adding details and accents in your illustrations.

Art Markers

Professional art markers create bold, vibrant bands of color. They are great for laying down large areas of even color, as well as for shading.

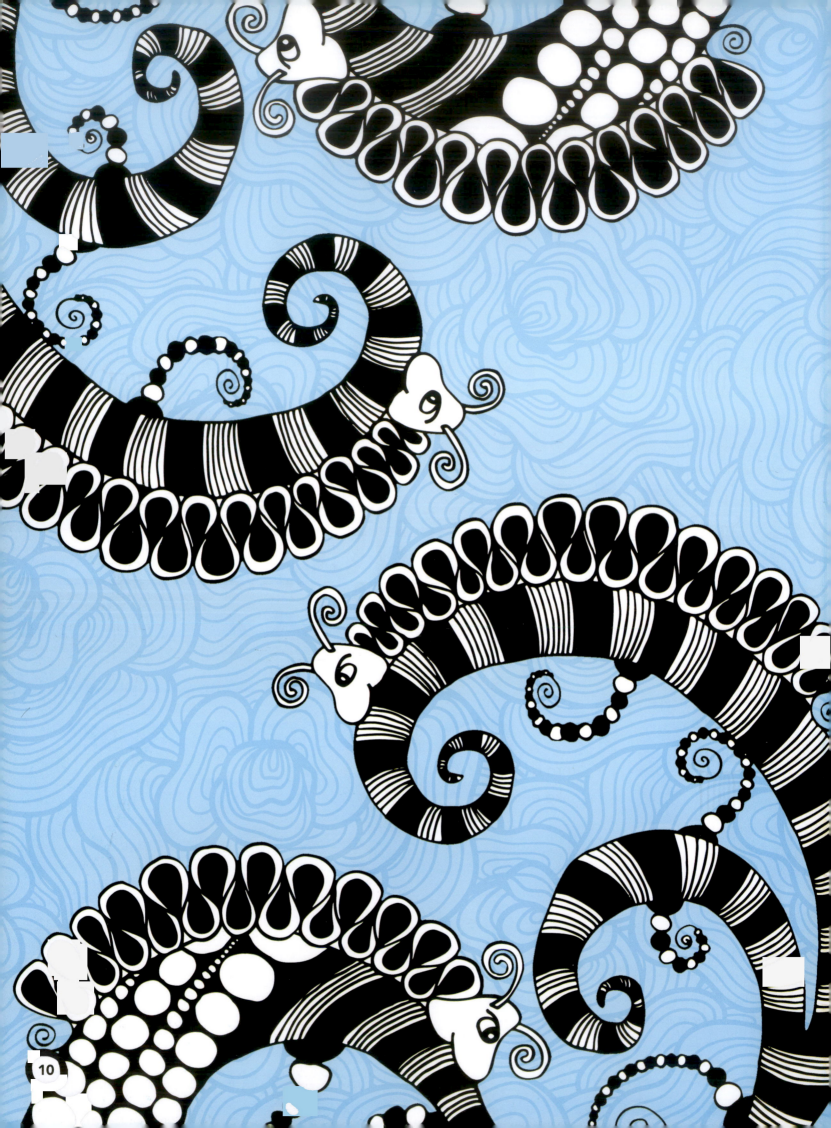

CHAPTER 1:
BASIC Tangles

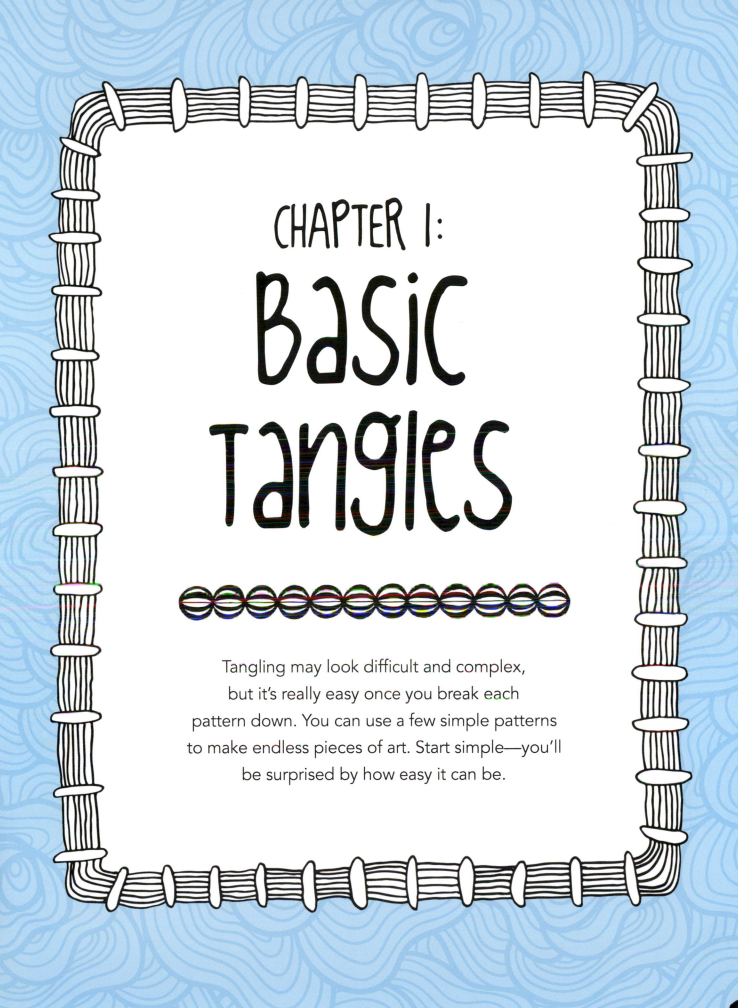

Tangling may look difficult and complex, but it's really easy once you break each pattern down. You can use a few simple patterns to make endless pieces of art. Start simple—you'll be surprised by how easy it can be.

○○○○○○ Straight Lines only! ○○○○○○

Tangling is the use of repetitive patterns to make art. In this section, only one pattern is used—the straight line! Take a close look at the drawings on these two pages, and you'll see that only straight lines have been used to create them. Use the templates on pages 110–113 to practice using straight lines only.

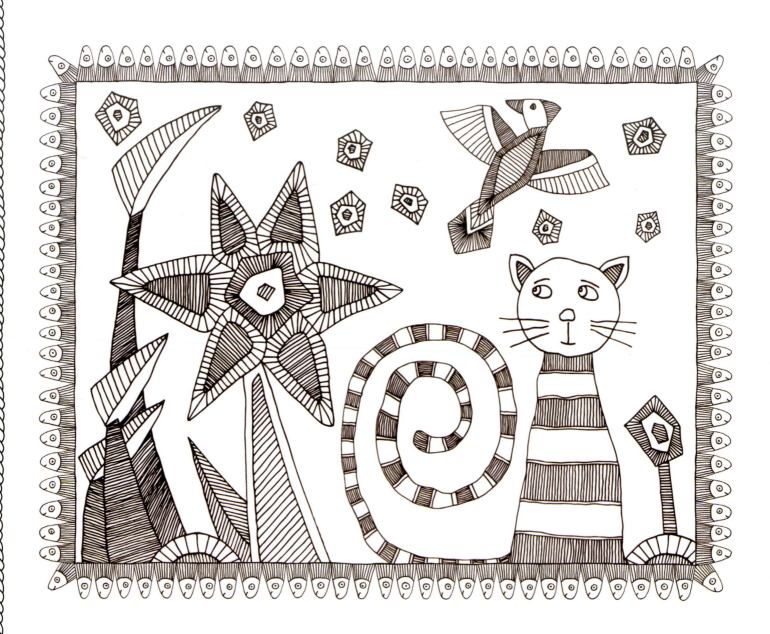

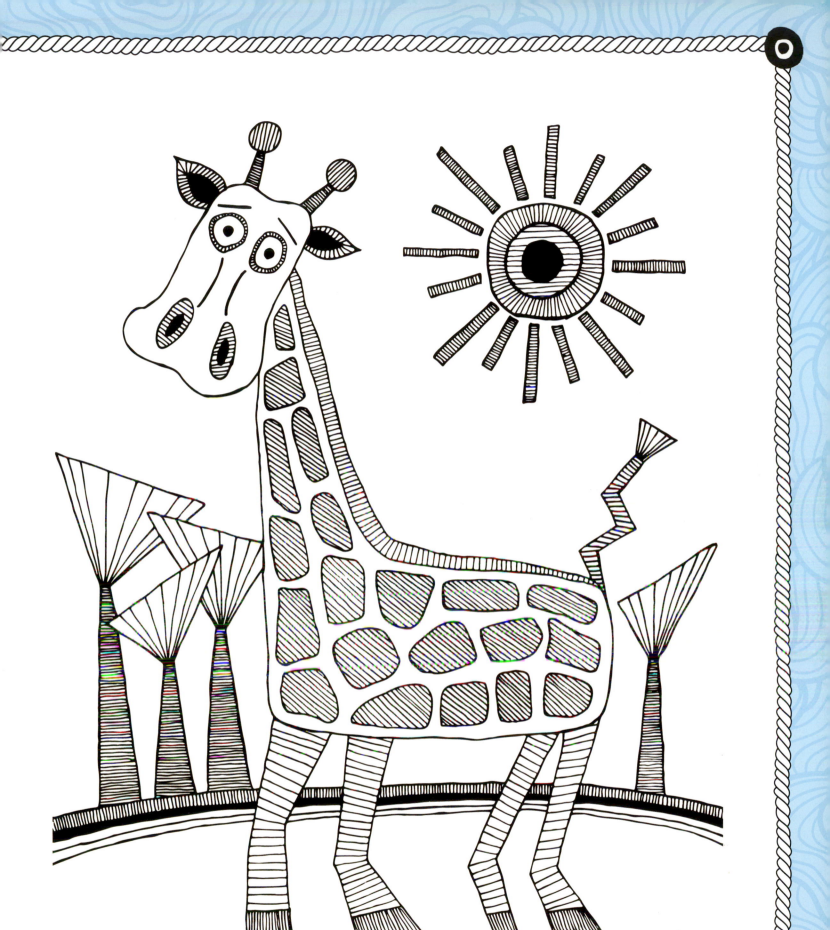

Borders & Patterns

Cute borders and cool patterns can really add a lot to your artwork. There are countless ways to create borders and patterns, from simple to ornate to whimsical. Try copying a few of the ones you see here, and then create some of your own.

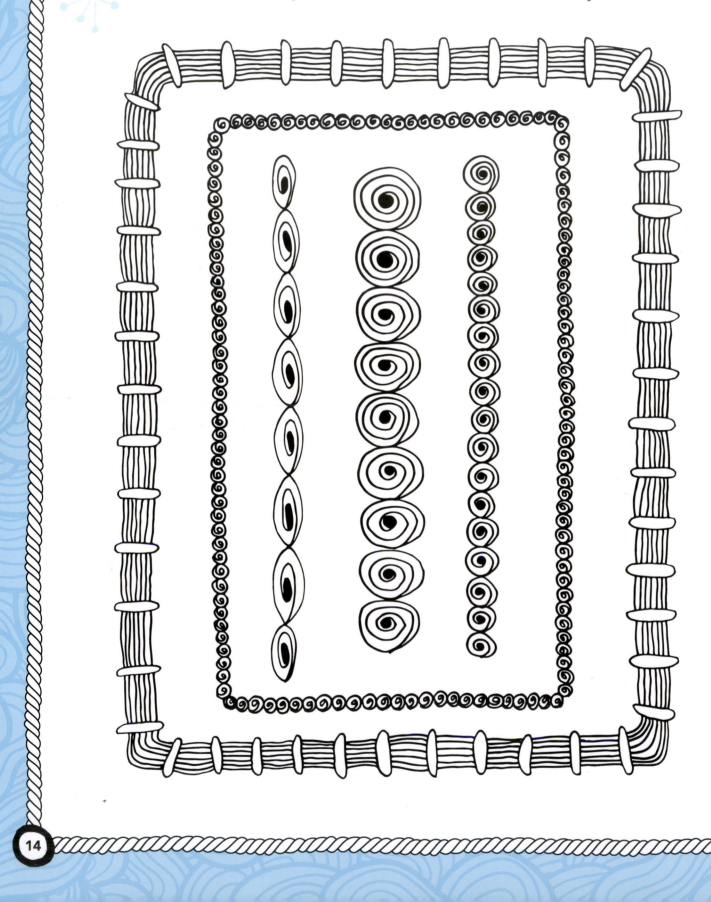

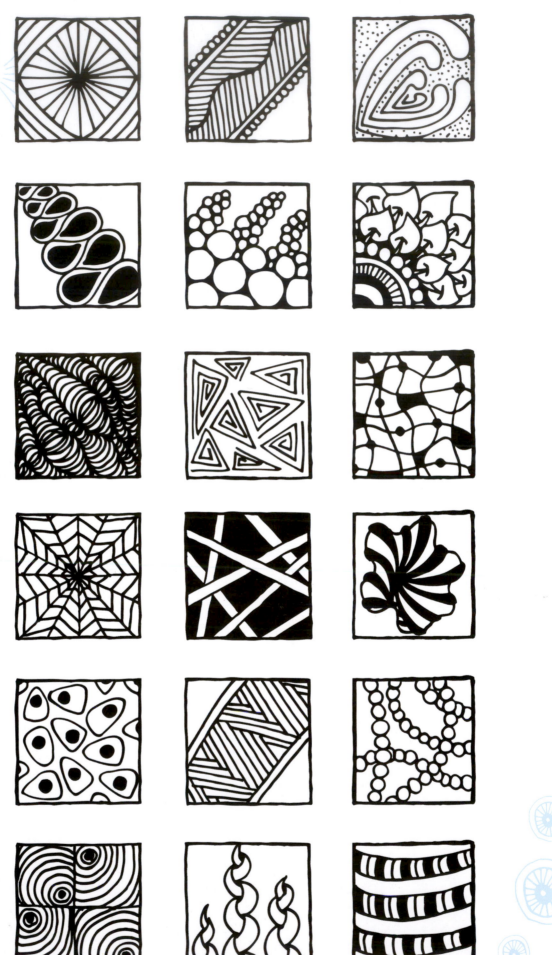

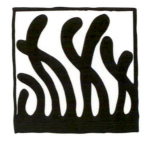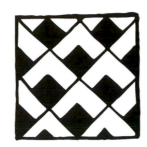
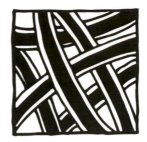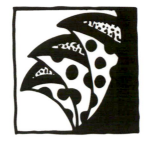
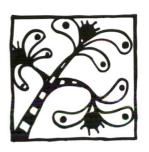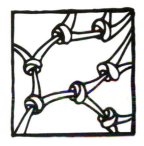
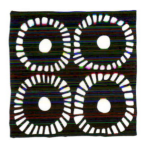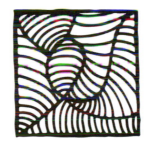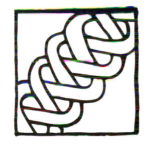
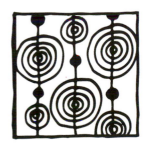

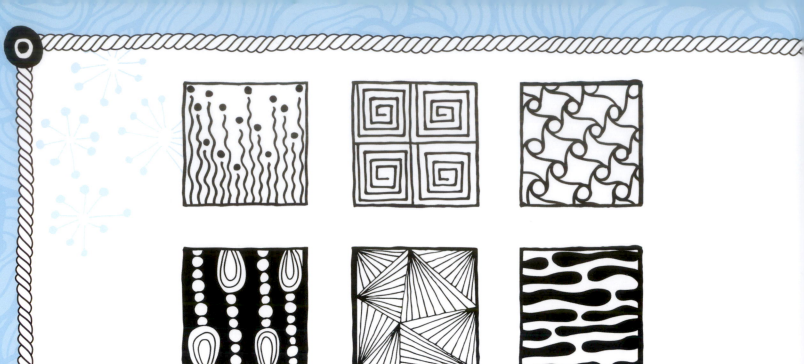

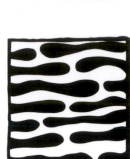

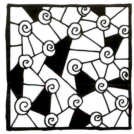
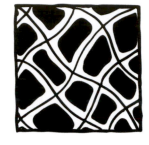
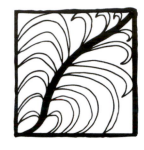

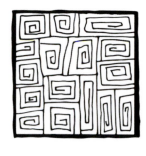
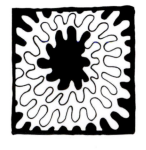

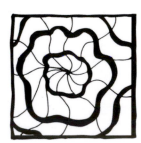
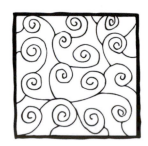

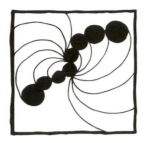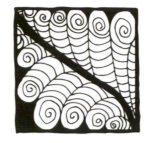
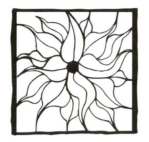
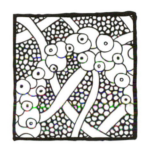
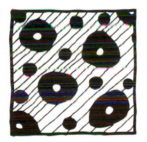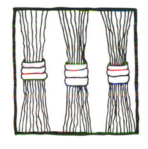
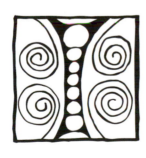

Tangly Arrows & Ribbons

Arrows and ribbons add a nice decorative touch to almost anything, and they're fun to draw. Use the next few pages as inspiration.

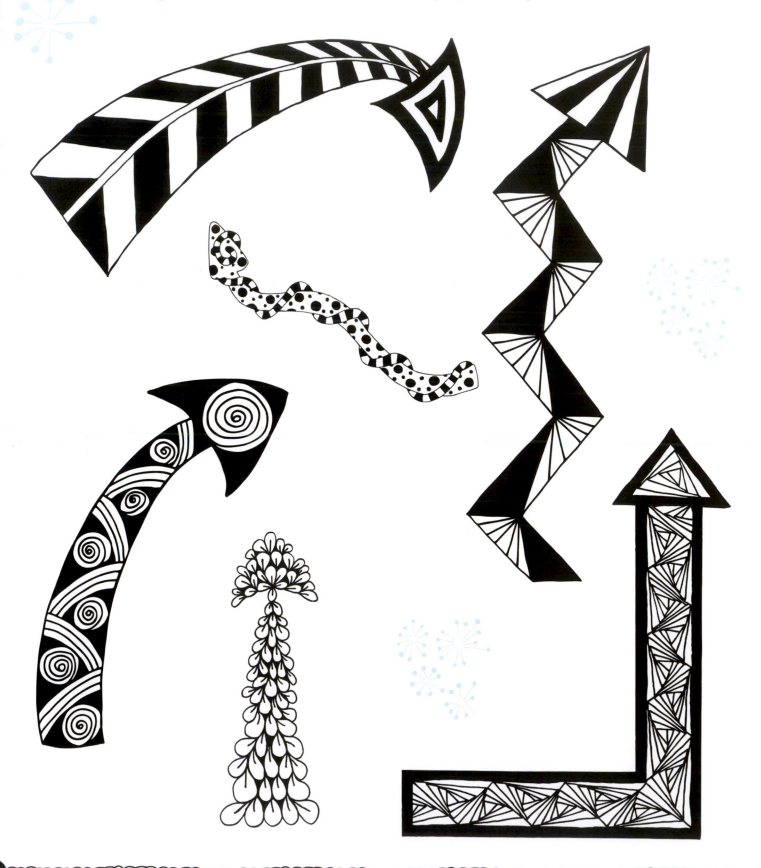

1

2

3

4

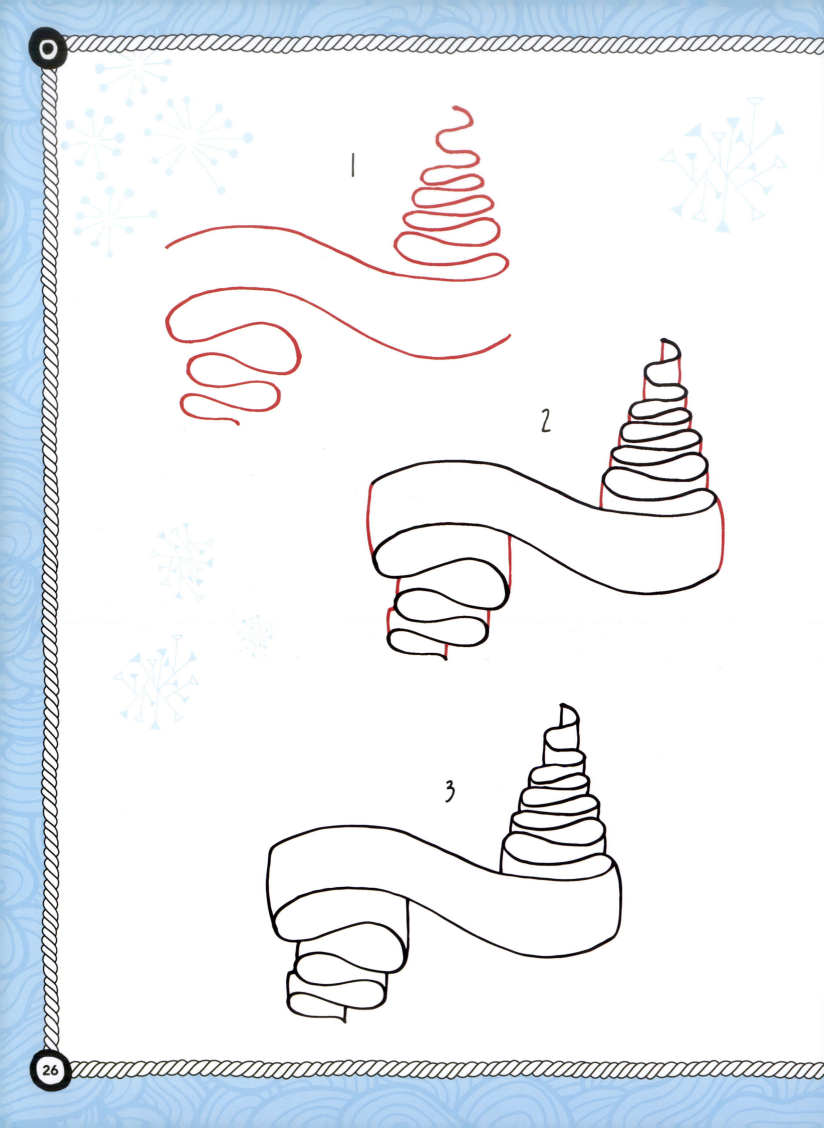

1

2

3

4

1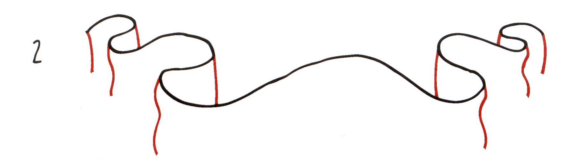

2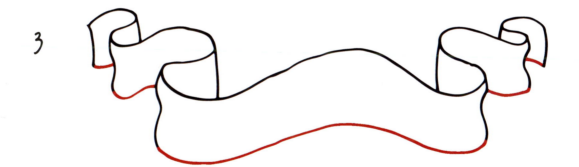

3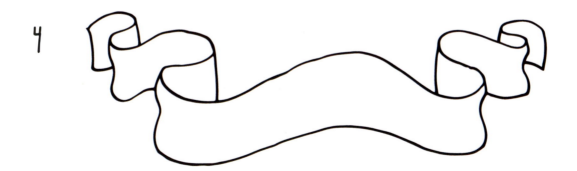

4

1

2

3

4

Using only the three simple patterns below (in red), you can create all sorts of fun designs. The possibilities are endless!

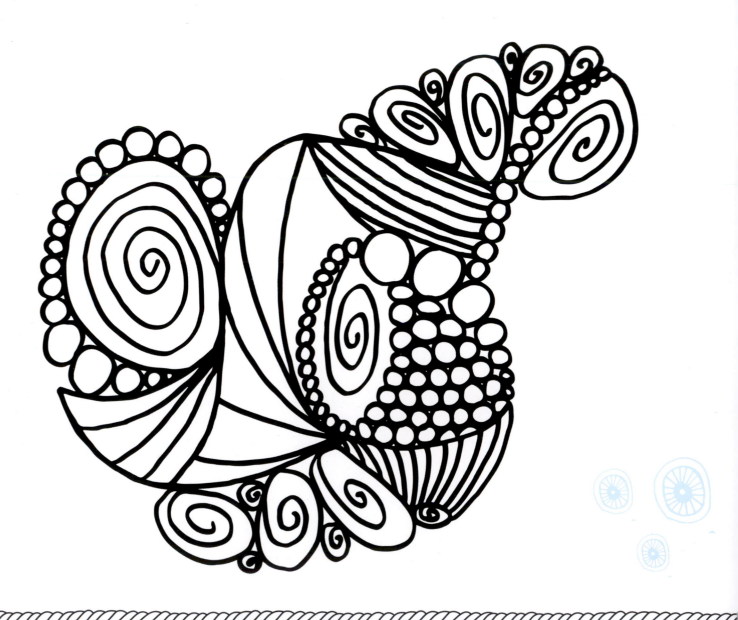

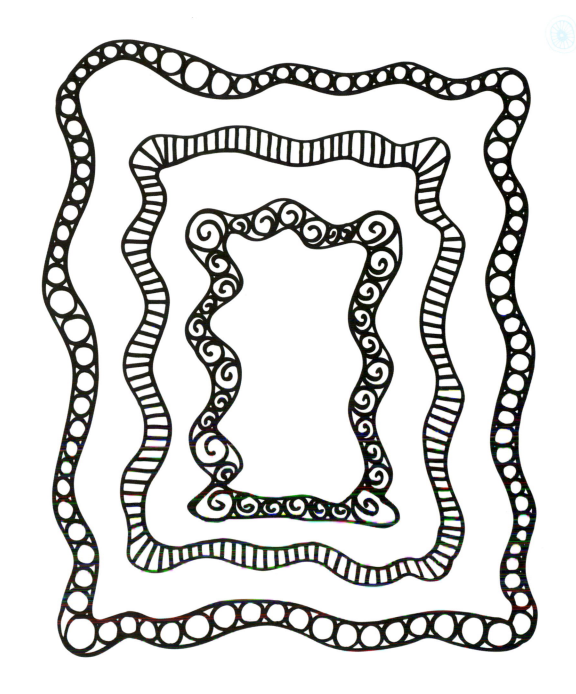

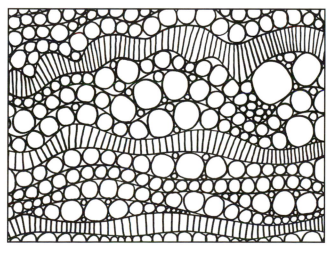

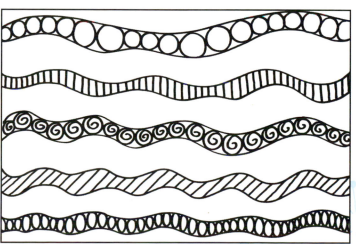

W2 Pattern

W2 (for Warp and Weft) is an official Zentangle® pattern by the art form's originators, Maria Thomas and Rick Roberts. This pattern seems complicated, but is simple when you take it step by step.

STEP 1 Draw a grid with small, squared dots spaced evenly apart.

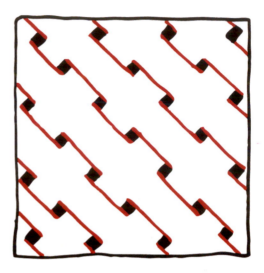

STEP 2 Connect the squares with straight lines moving in one direction—one on the left, and then one on the right.

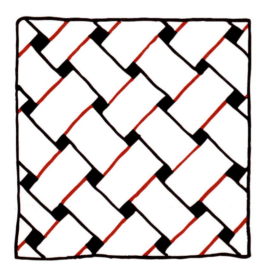

STEP 3 Next connect the squares by drawing lines in the other direction.

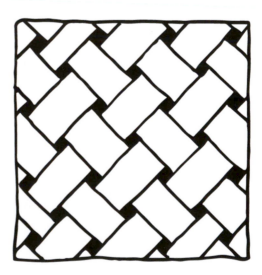

STEP 4 The end product should look similar to a woven basket.

W2 Variations

Use curved lines to connect the round dots.

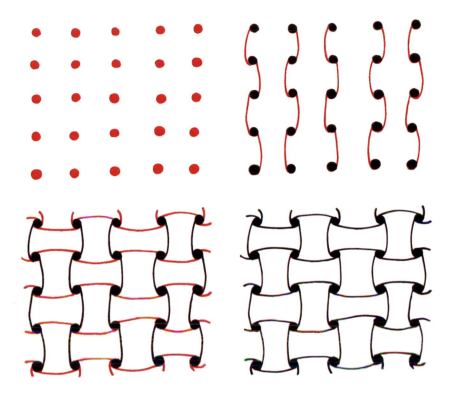

Expand the squared-dot grid at one end.

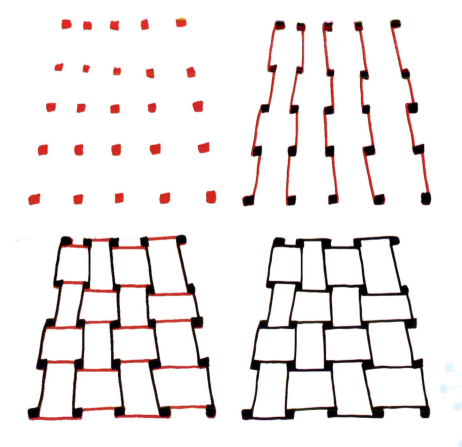

○○○○○○○○ Saturn Pattern ○○○○○○○○

This pattern is a fun and creative way to fill space.
Can you guess why it's called Saturn?

STEP 1 Start by drawing a semicircle and filling it in.

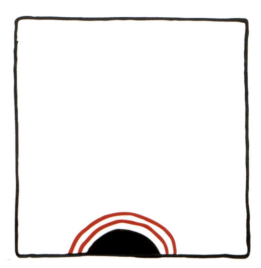

STEP 2 Add two semicircles around it.

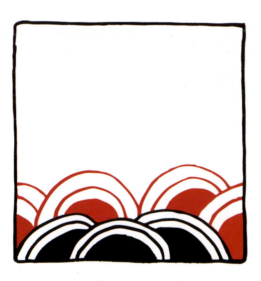

STEP 3 Continue building the pattern by adding more semicircles and rings.

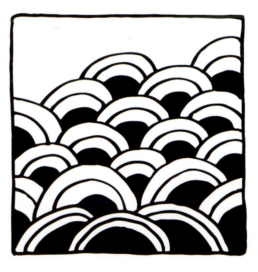

STEP 4 Keep going until you fill the entire area.

Saturn variations

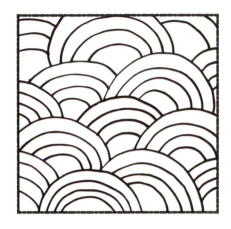 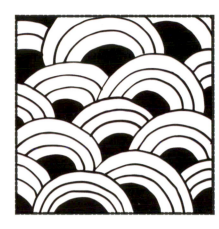 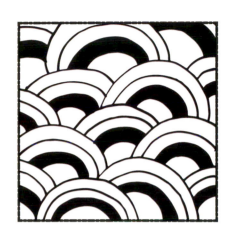

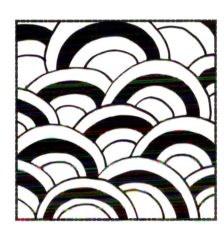 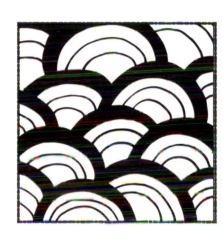 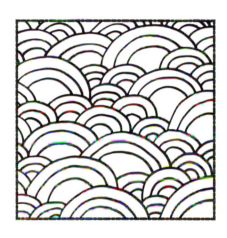

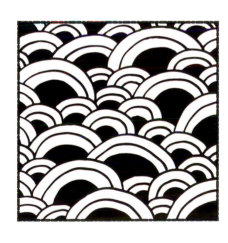 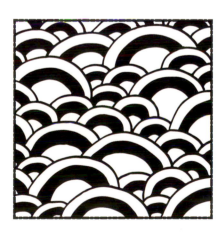 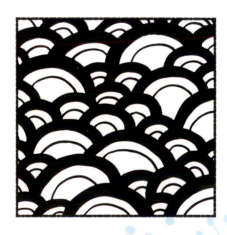

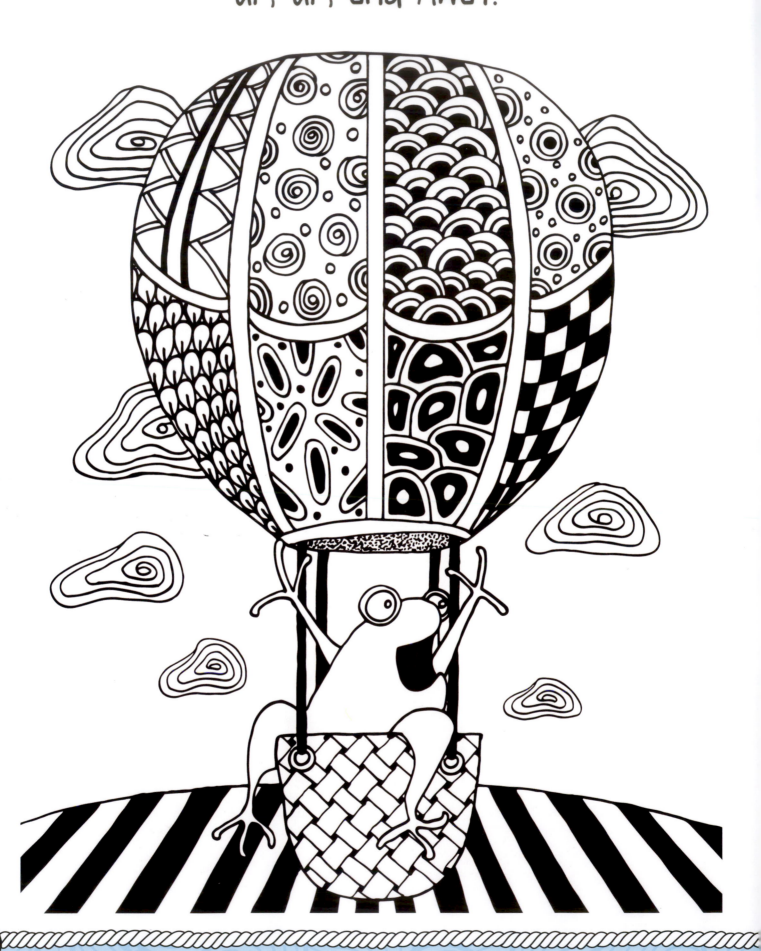

This charming hot air balloon is made up of the W2 and Saturn patterns, as well as the patterns shown below. Try making your own patterns using the template on page 114.

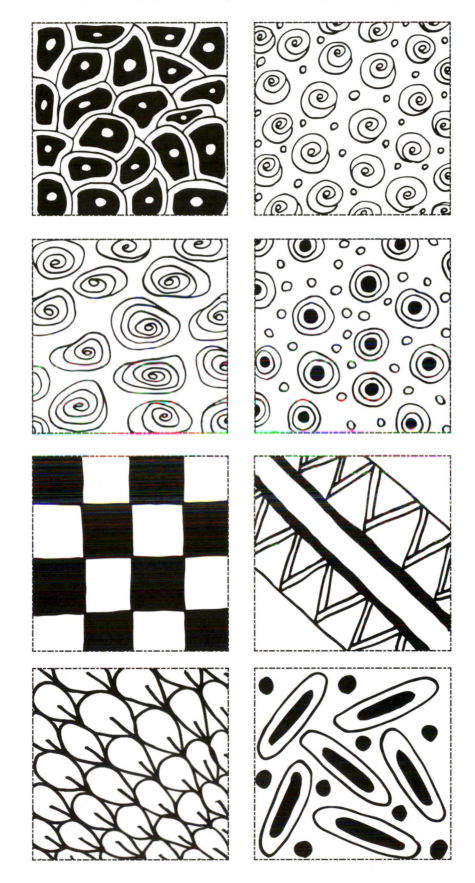

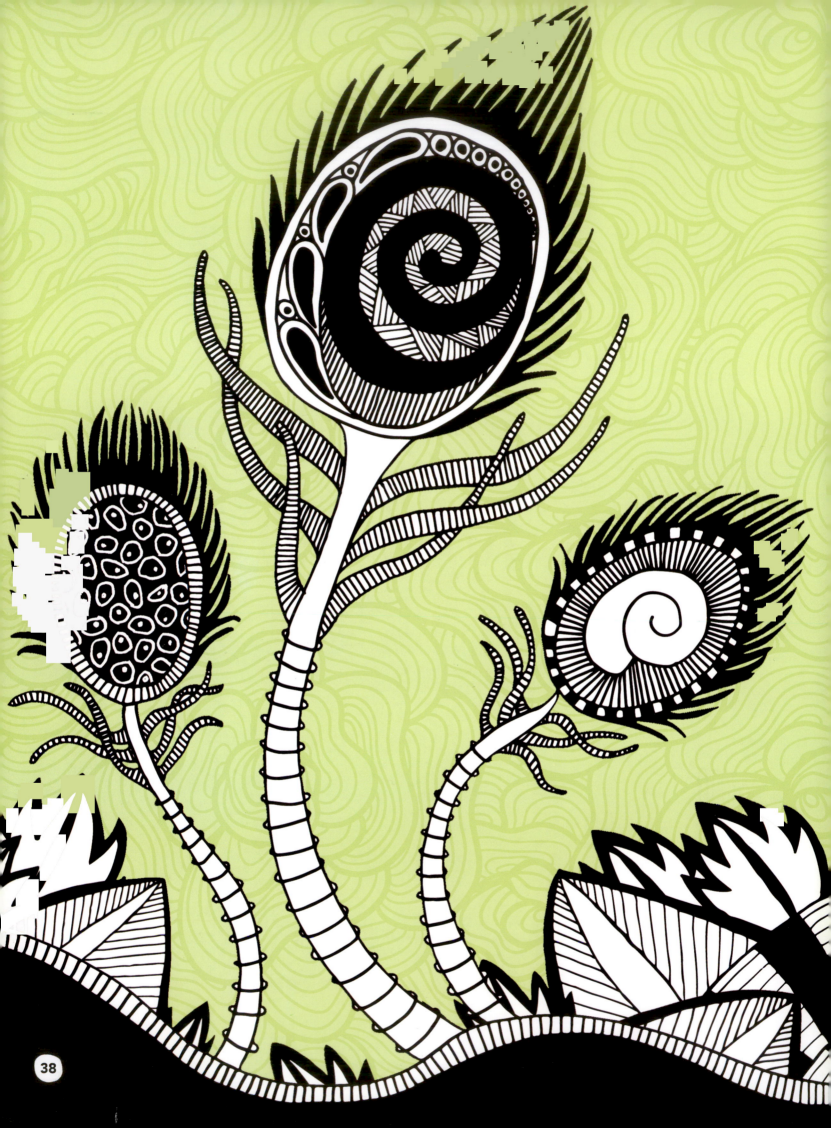

CHAPTER 2:
Tangled Up in Nature

Learn to draw more complex patterns, and create
your very own tangled fantasy garden
or underwater world!

Phicop Pattern

STEP 1 Draw a circle with a pencil.

STEP 2 Divide the circle into 8 parts, as if you were cutting a pie.

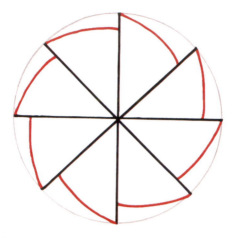

STEP 3 Connect the lines as shown.

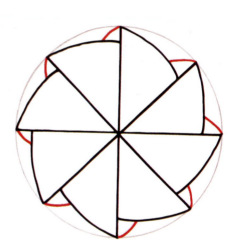

STEP 4 Connect more lines as shown.

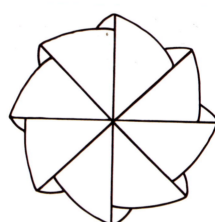

STEP 5 Erase the pencil circle.

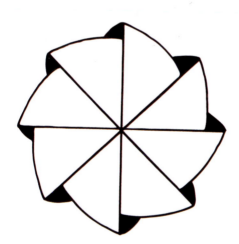

STEP 6 Fill in as shown.

Phicop variations

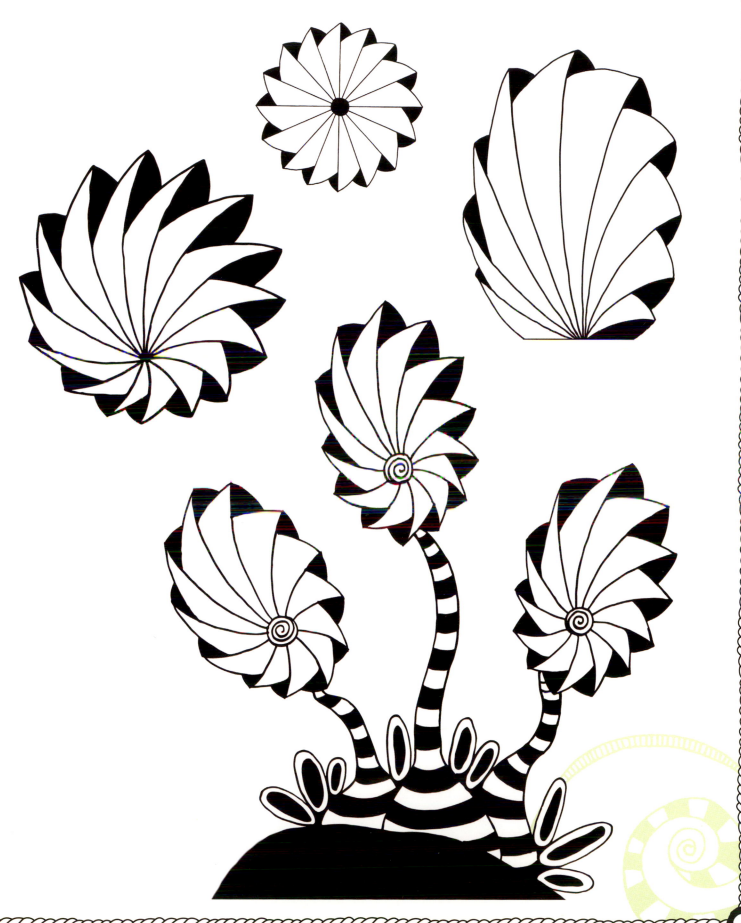

STEP 1 Draw a circle with a pencil.

STEP 2 Draw a squiggly line for the stem.

STEP 3 Add a petal.

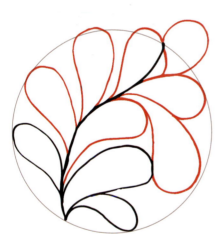

STEP 4 Continue adding petals on both sides of the stem.

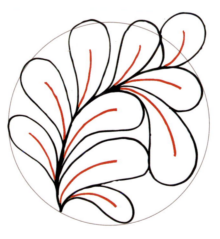

STEP 5 Draw a line within each petal to mimic veins.

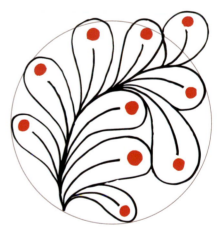

STEP 6 Add a dot at the tip of each petal.

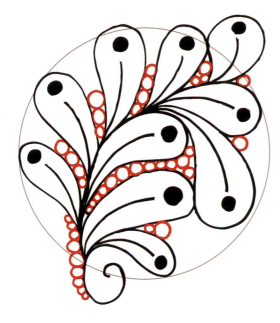

STEP 7 Add circles between the petals.

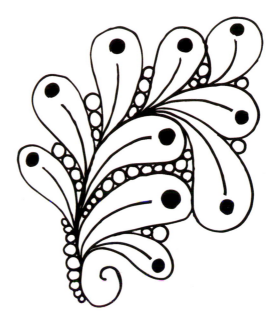

STEP 8 Erase the pencil circle.

Petal Variations

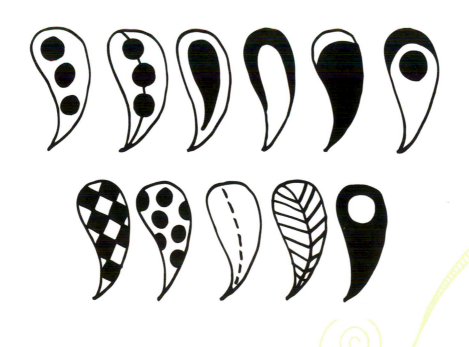

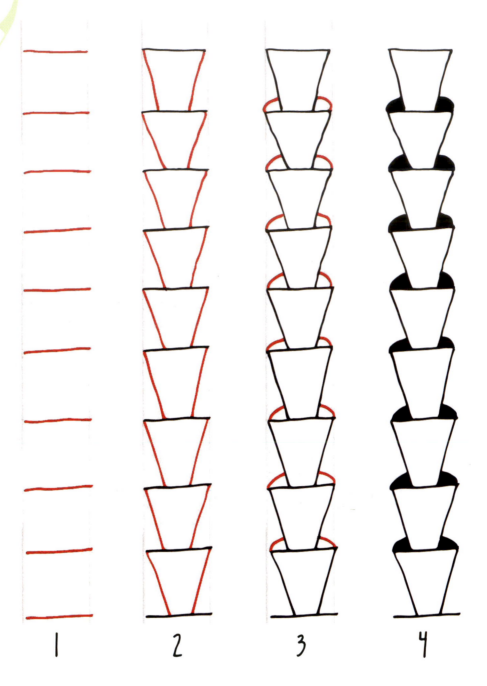

1 2 3 4

Artist's Tip

This pattern consists of drawing and connecting
lines and filling in small areas. It's super easy!

Stackem variations

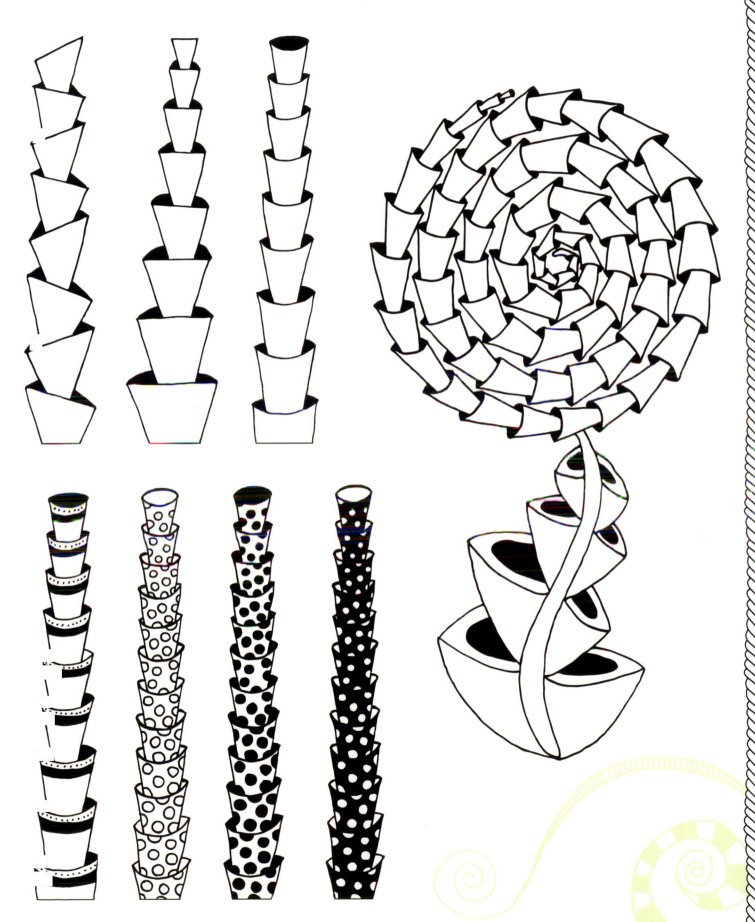

Pokeroot Pattern

Pokeroot is one of the original Zentangle® patterns created by Maria Thomas. Its flowing and whimsical feel makes it popular among tanglers.

STEP 1 Draw a narrow stem.

STEP 2 Add a round circle at one end of the stem—think of a berry.

STEP 3 Add an arch at the tip of the stem.

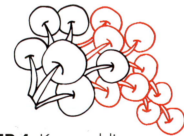

STEP 4 Keep adding stems and berries.

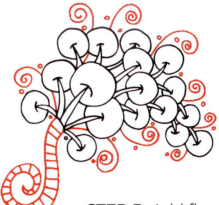

STEP 5 Add flourishes behind the berries to give your tangle more dimension. Add a striped root.

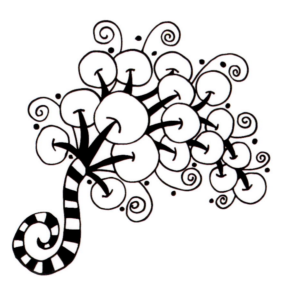

STEP 6 Fill in the stems, the stripes on the root, and the small dots in the flourishes.

Pokeroot variations

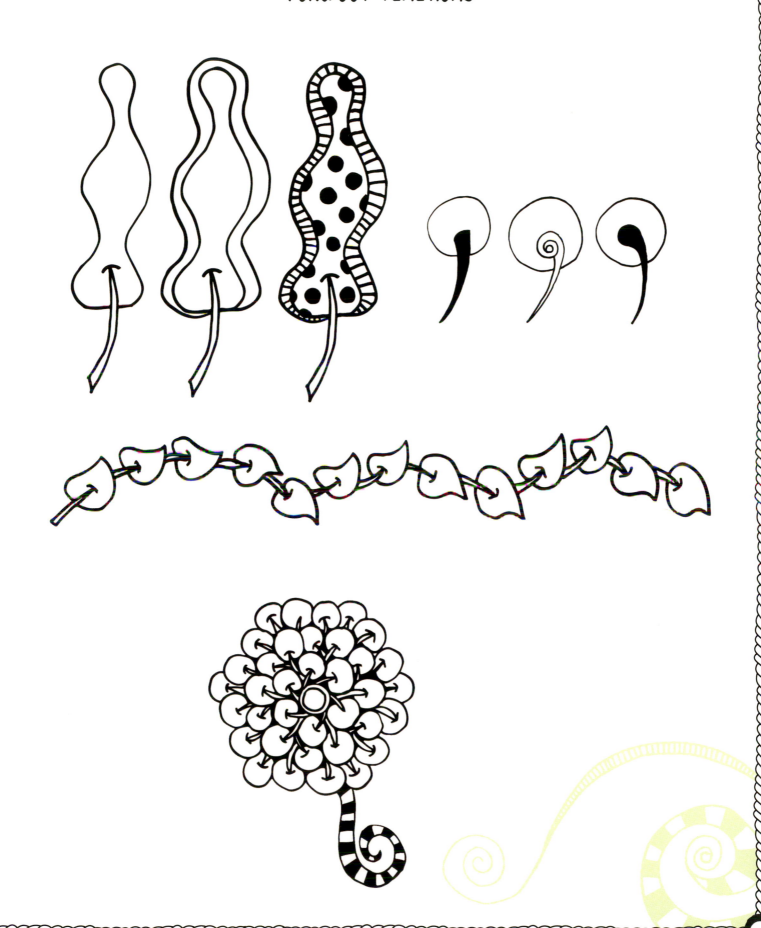

Tangling patterns can be used to create many different flowers.
Here are some examples of flowers you can add to your garden!

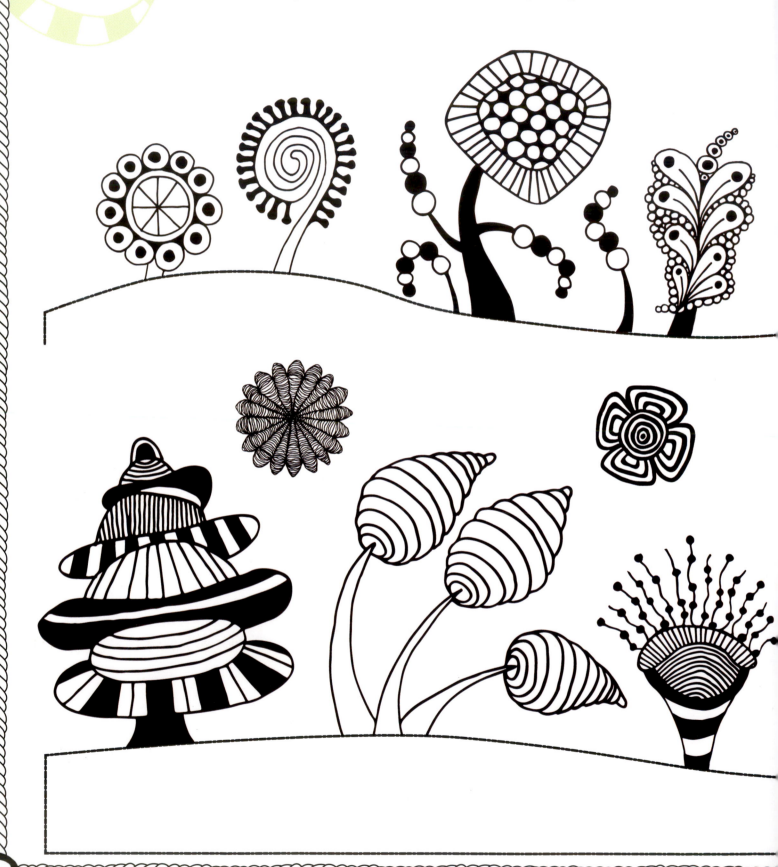

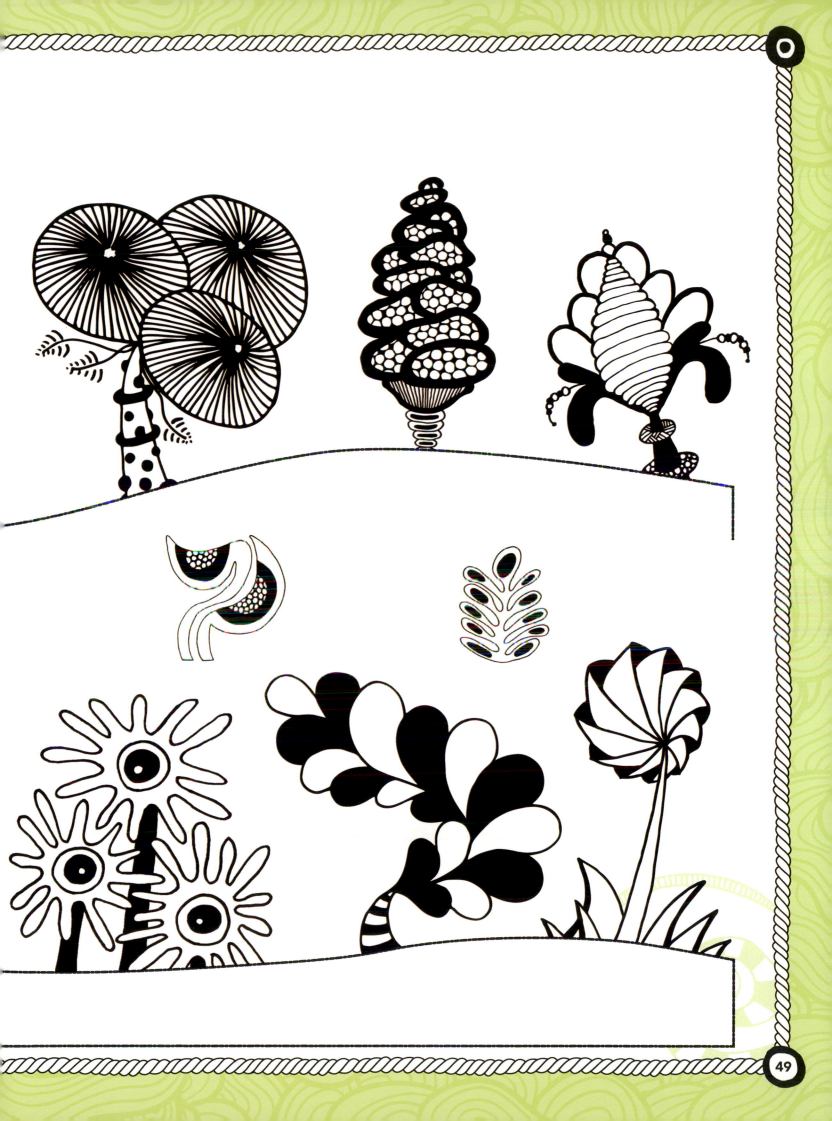

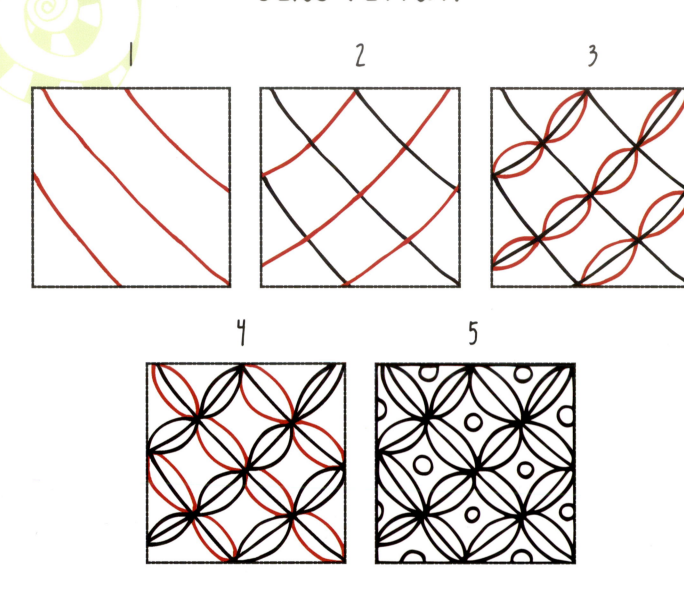

1　　　2　　　3

4　　　5

Bales variations

ᴏᴏᴏᴏᴏᴏᴏᴏ BeaDline Pattern ᴏᴏᴏᴏᴏᴏᴏ

1 2 3

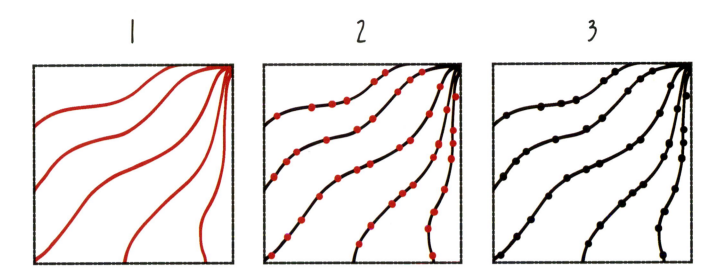

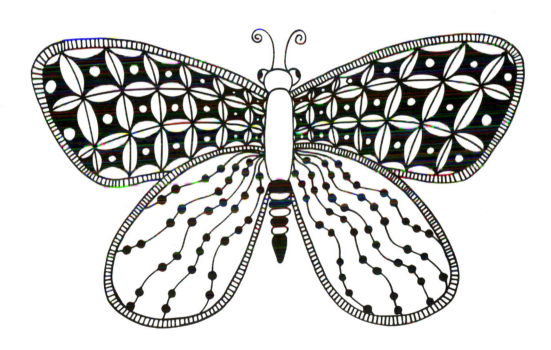

Create beautiful butterflies using the patterns
on the following pages. Once you're finished, you
can cut them out and make a hanging display.

1

2

3

4

5

6 7

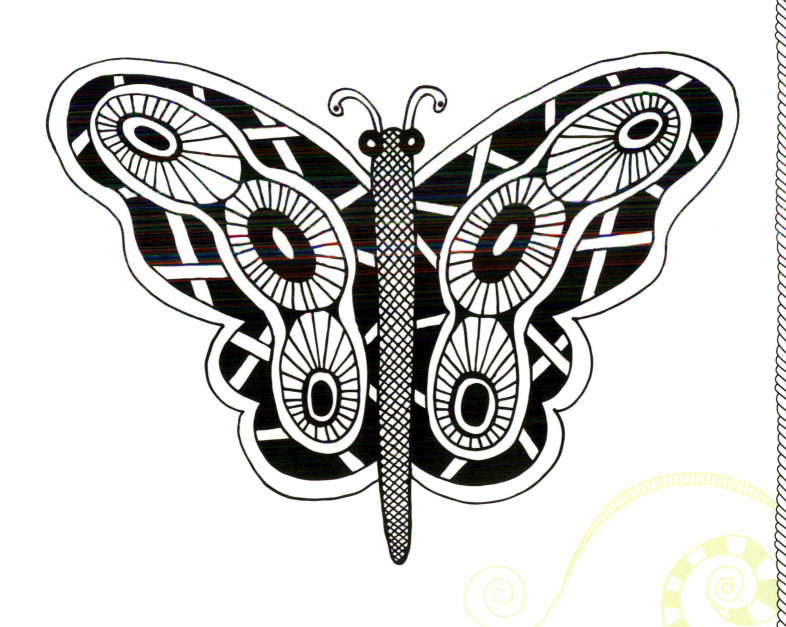

1

2

3

4

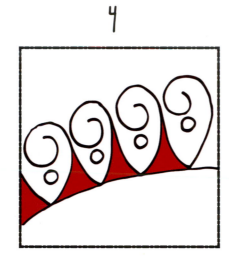

5

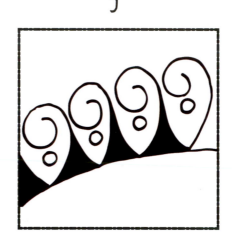

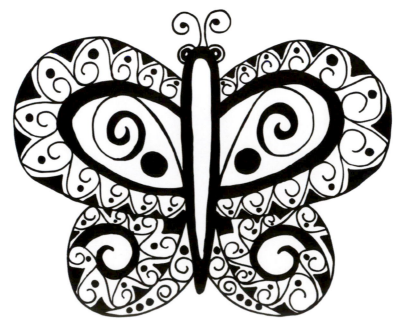

1

2

3

4

5

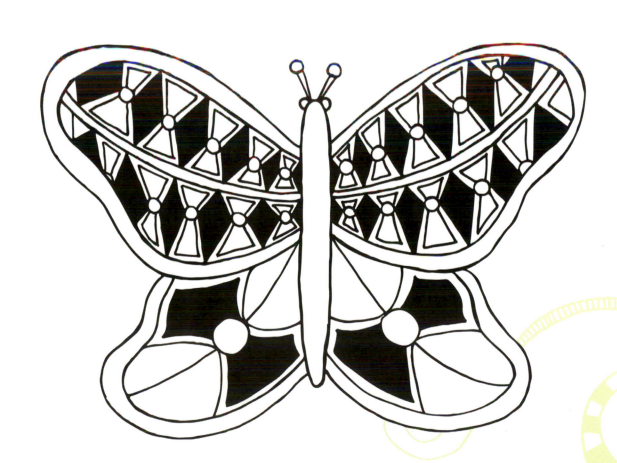

Now design your own butterfly, using the designs below as inspiration.

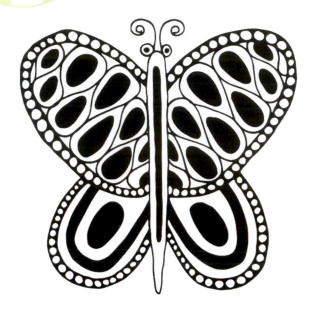

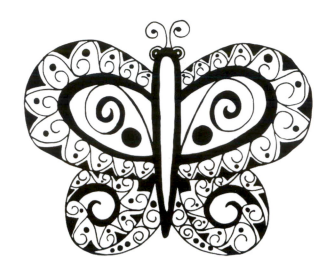

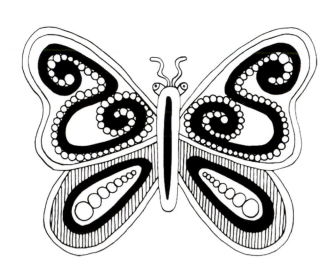

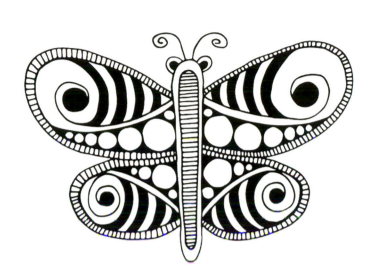

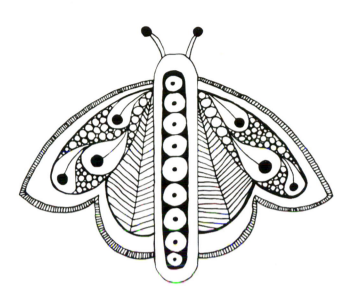

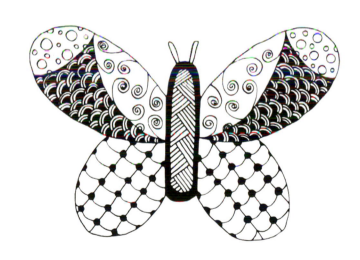

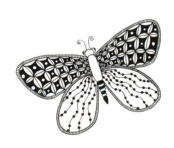

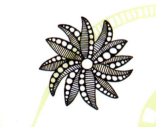

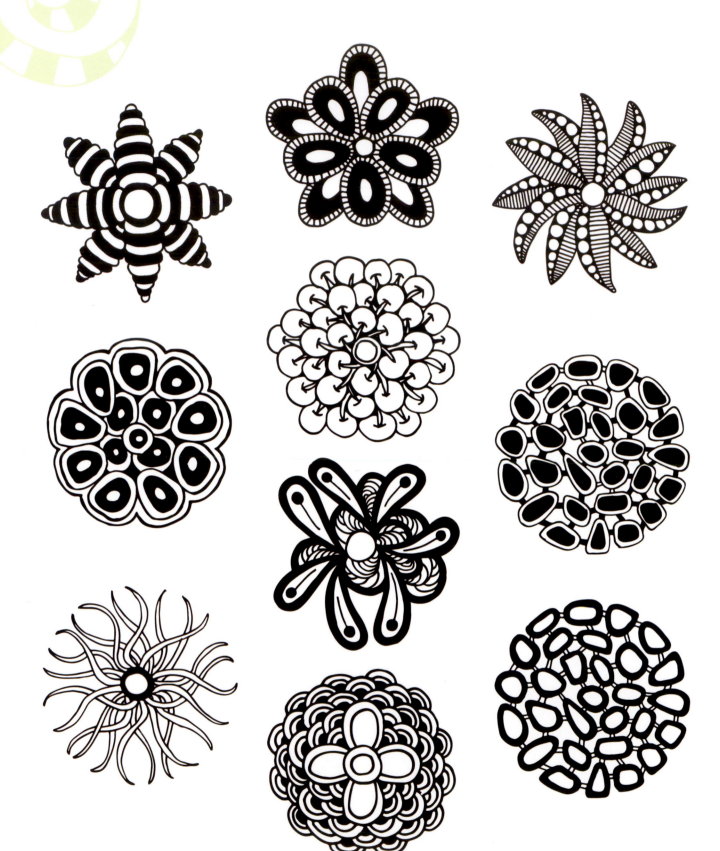

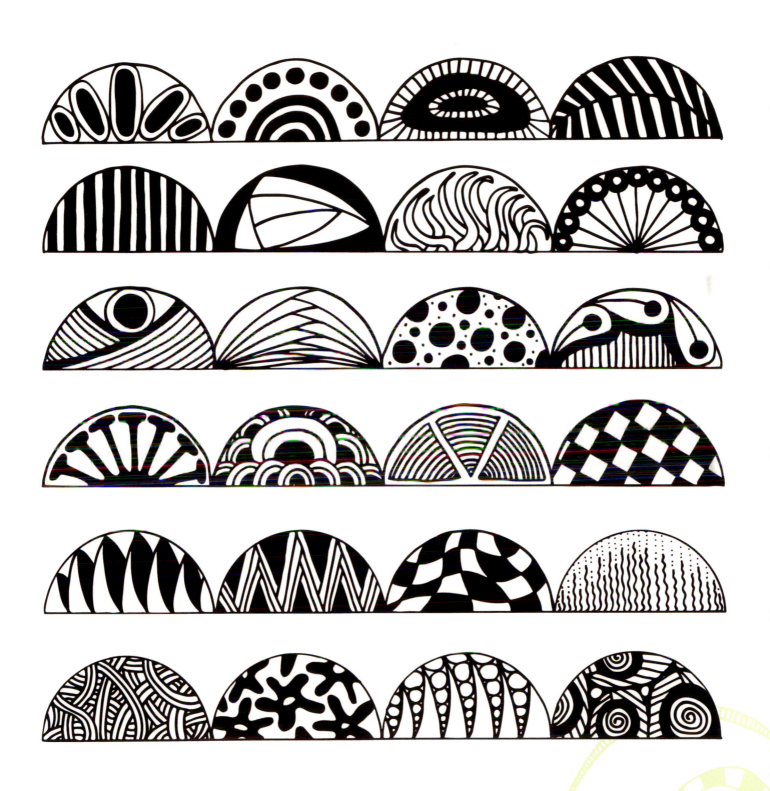

Use the pretty patterns from pages 58–59 to create tangled peacock feathers and ornate designs. Try drawing a unique feathered friend of your own!

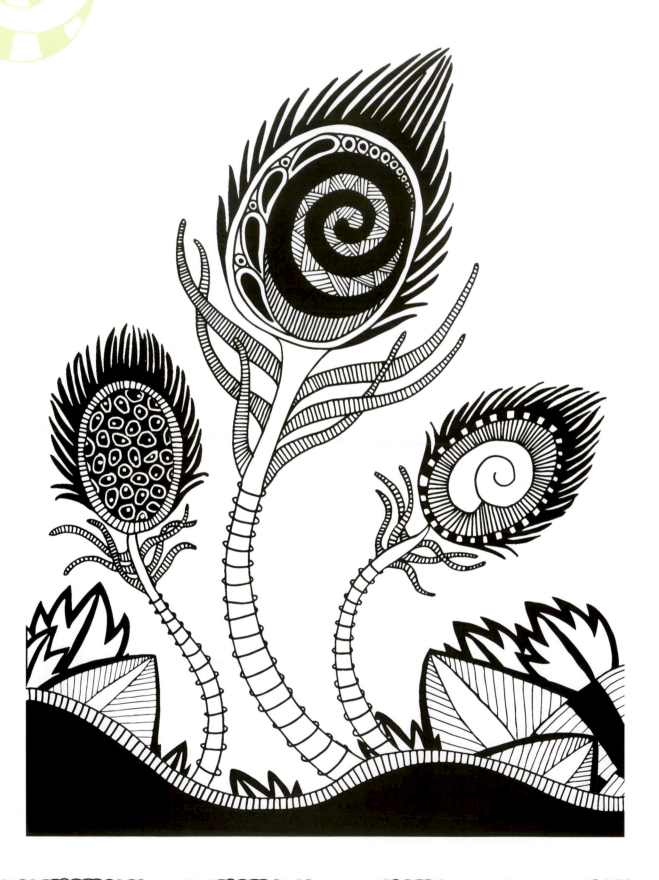

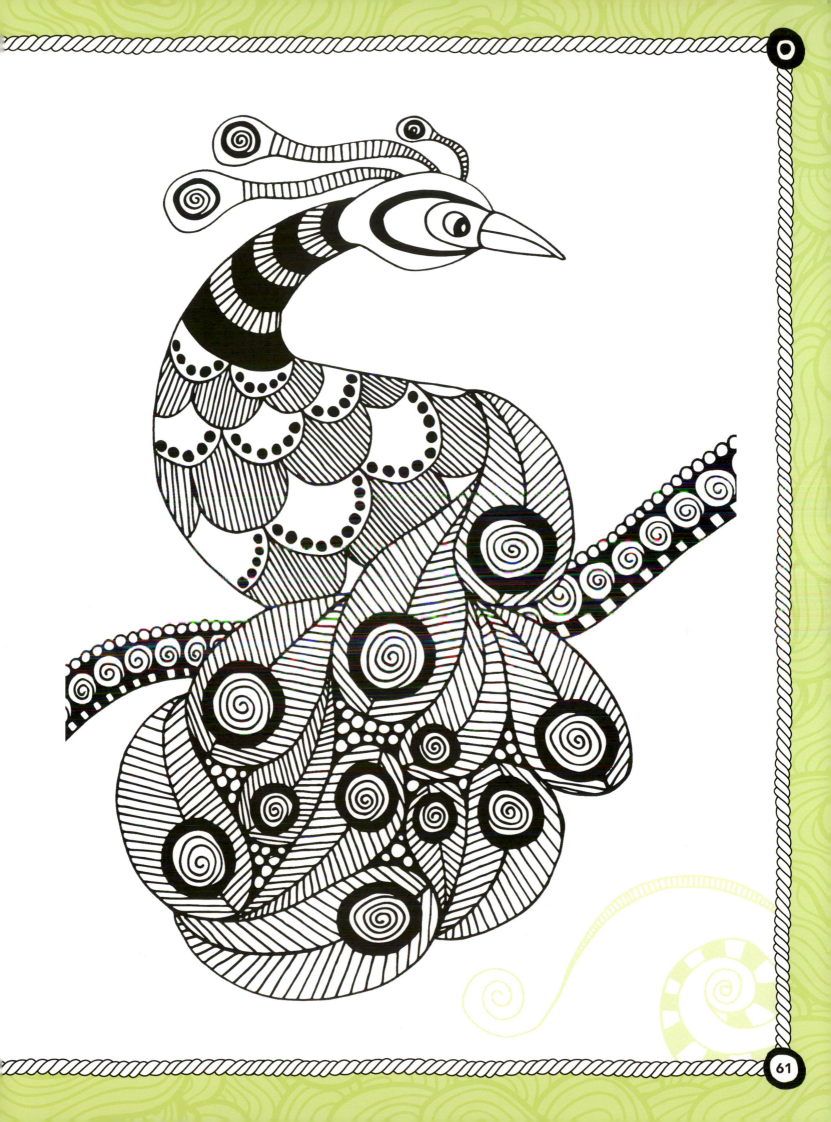

Pepper Pattern

Draw a circle, oval, or squiggly shape with a pencil, and add a small circle anywhere inside. Switch to a pen and draw petals as shown. When done, erase the pencil marks.

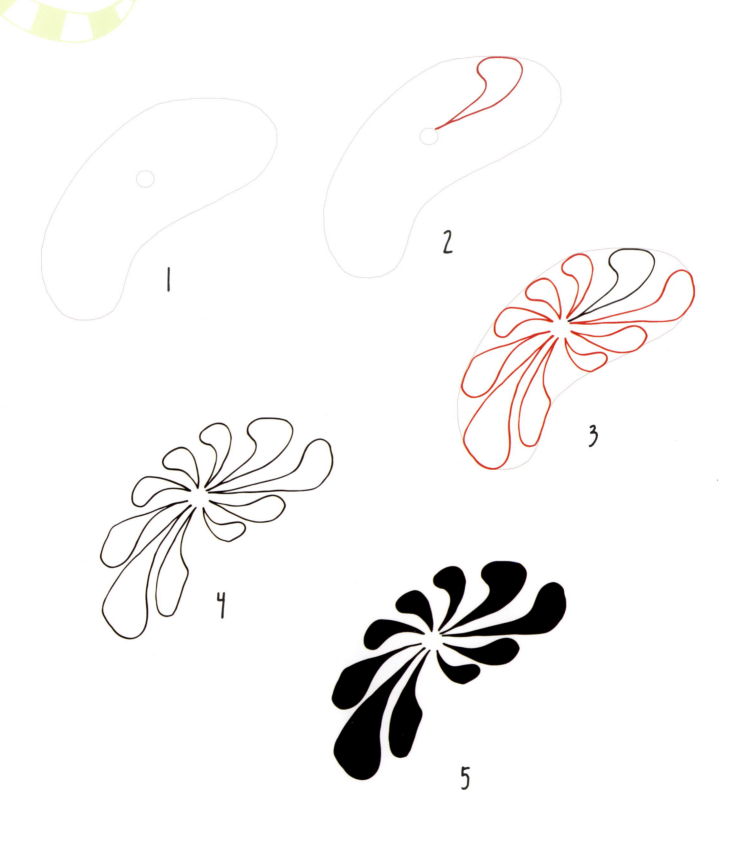

1

2

3

4

5

Pepper variations

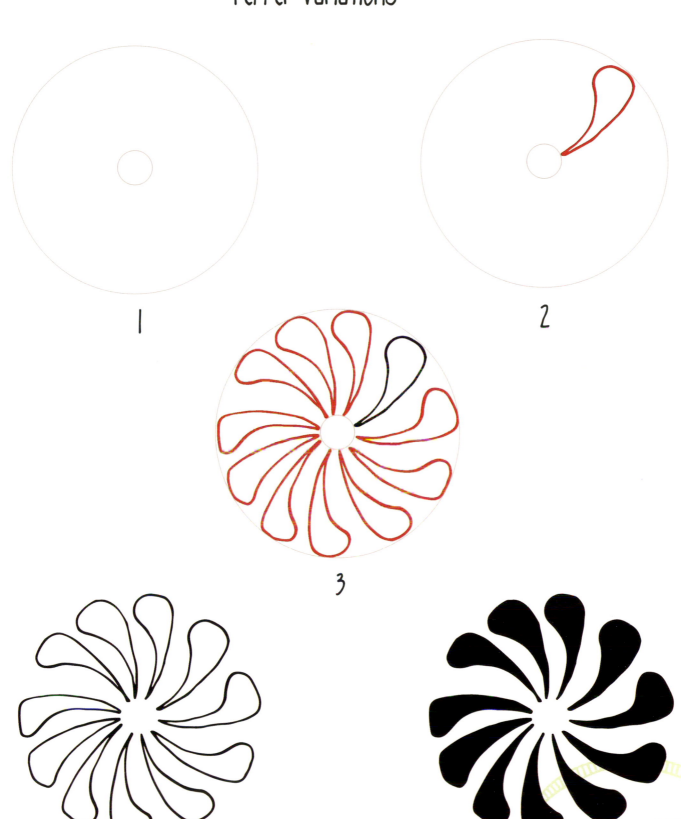

1

2

3

4

5

Tripoli Pattern

Every garden needs bugs! Follow the steps below to create the Tripoli pattern.
Draw the two circles with a pencil, and erase them once you're done.

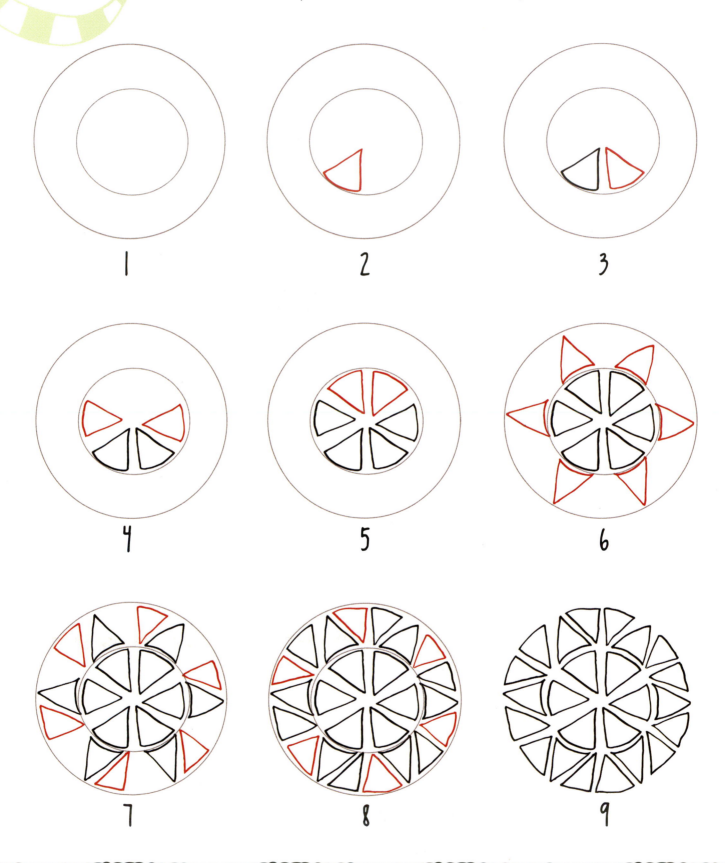

1

2

3

4

5

6

7

8

9

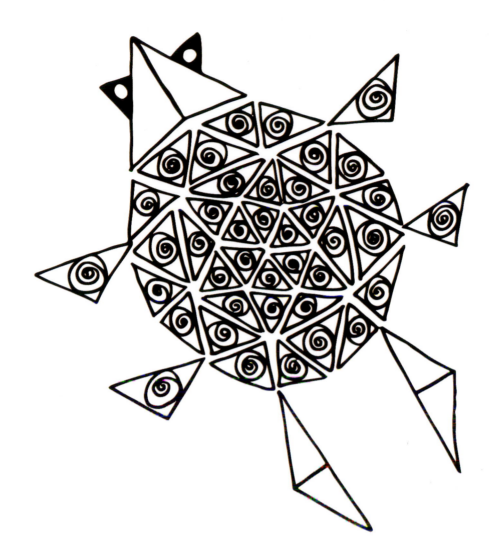

After you've completed all the pie shapes, go back and
add a unique design to each one. See the examples below.
Have fun with it, and create your own designs!

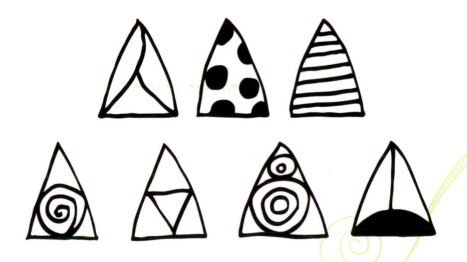

⚬⚬⚬⚬⚬⚬⚬⚬ Loop Pattern ⚬⚬⚬⚬⚬⚬⚬⚬

Start by drawing a loop, and then add more. After you've drawn a few, start adding teardrop shapes inside each loop. Then fill each teardrop, and voilà, you have a creepy-crawly friend!

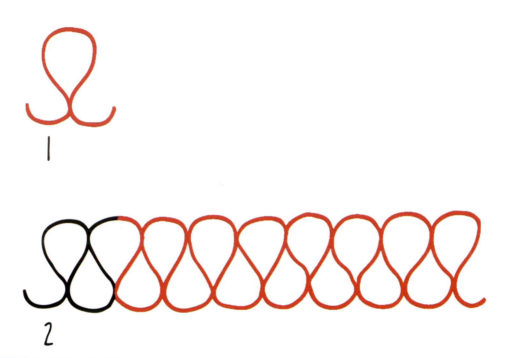

1

2

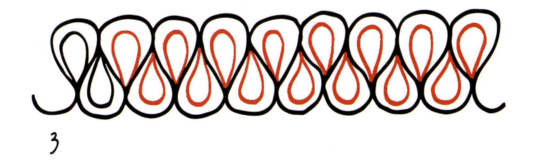

3

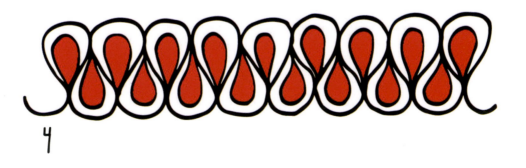

4

5

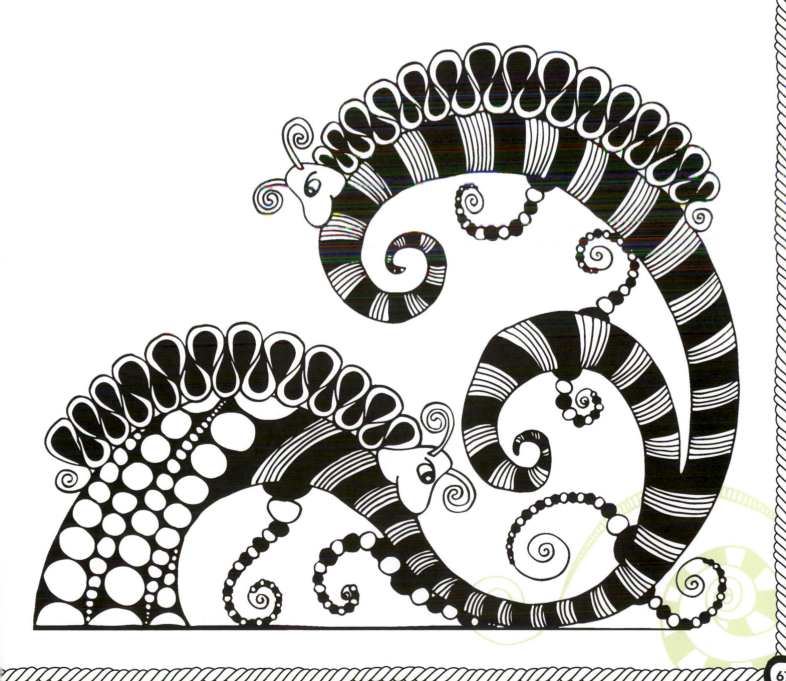

Worms

Worms are easy and fun to draw! Start by drawing an ellipse, as shown below.
Add arches above and below. You can go back and forth without lifting your pen.
You can also start with a circle or an ellipse and draw arches in only one direction,
varying the size of the arches.

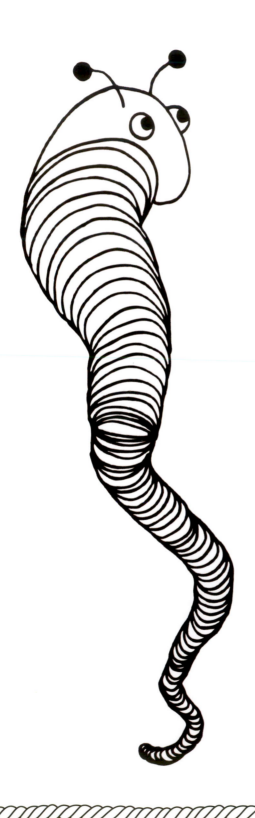

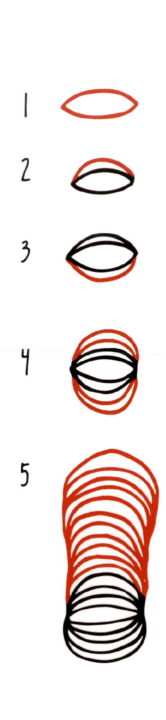

1

2

3

4

5

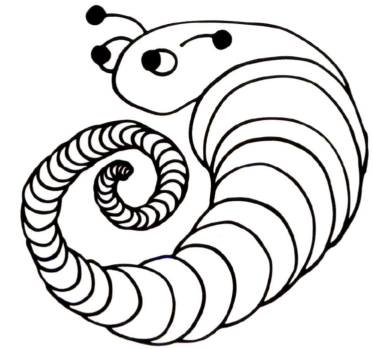

1

2

3

4

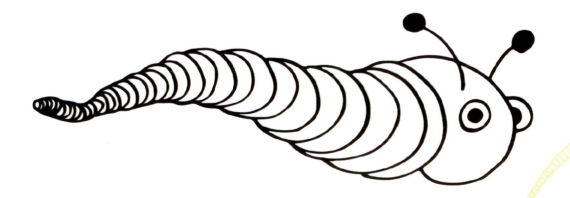

Use the tangles below as inspiration
to create your own underwater world.

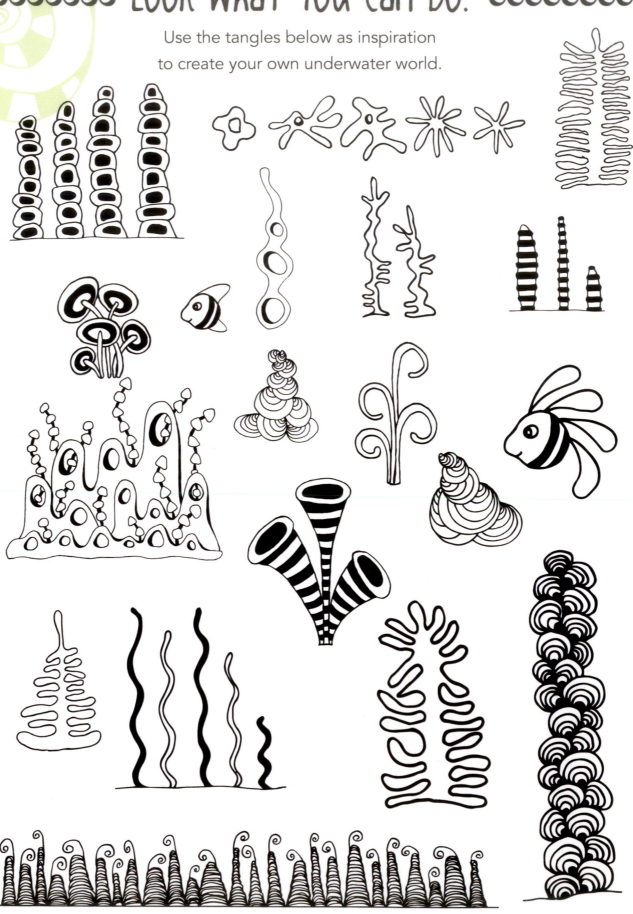

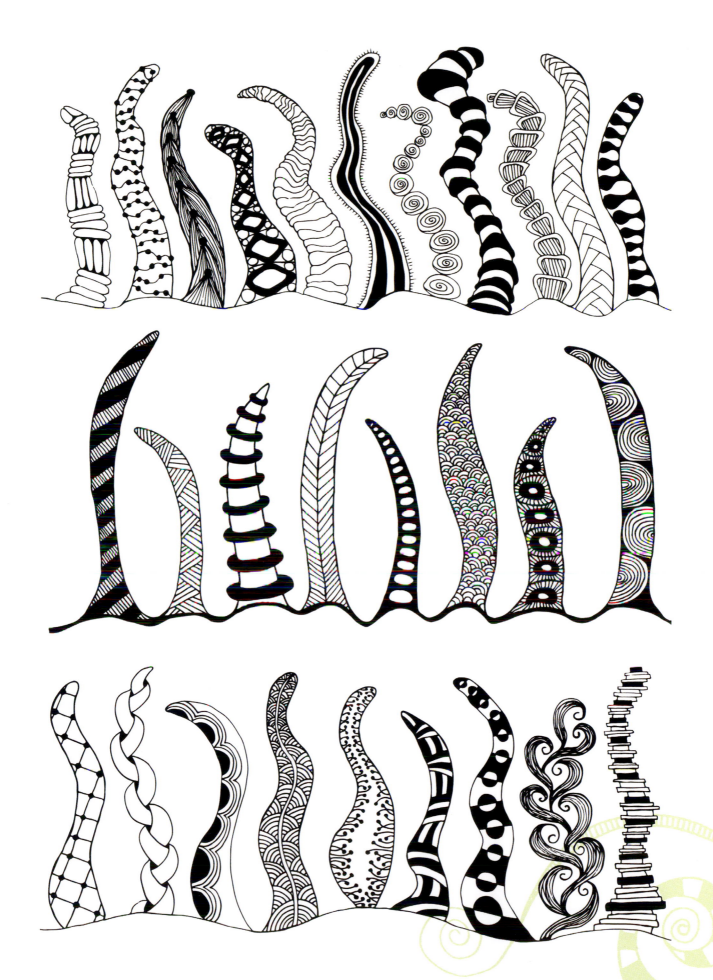

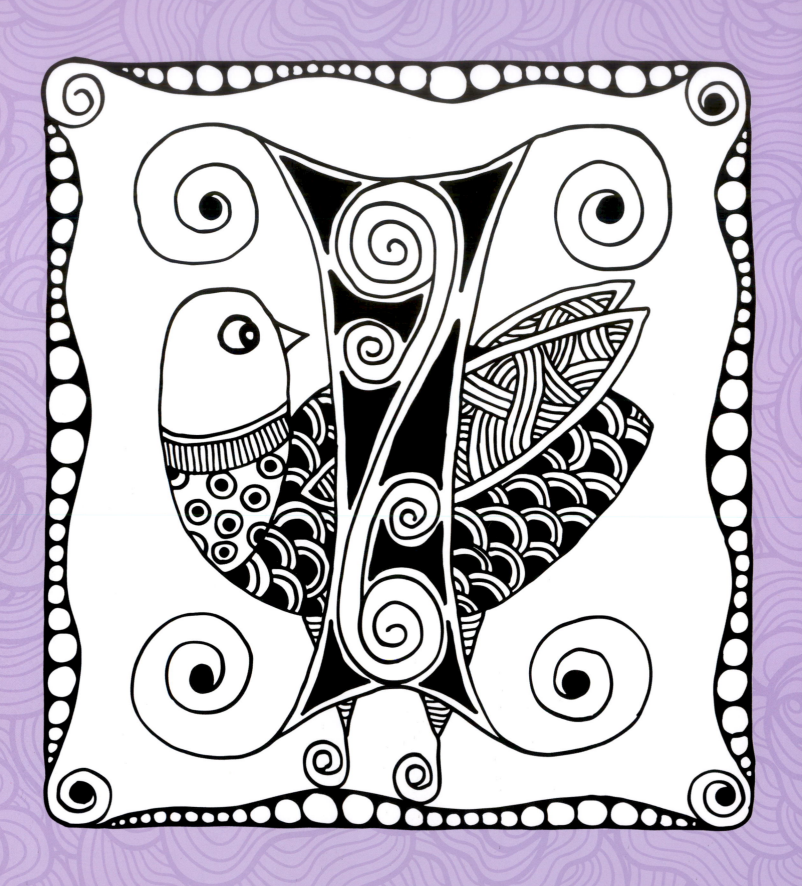

CHAPTER 3: Tangled Letters & Numbers

Take doodling to the next level by decorating letters and words with whimsical patterns! Add a personal touch to notebooks, journals, and cards by creating your own unique alphabet or awesome illuminated letters.

Tangled Alphabet

Create a one-of-a-kind alphabet using tangling patterns.
Try using a unique pattern for each letter!

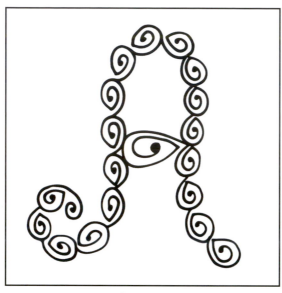

Ansu

Barberpole

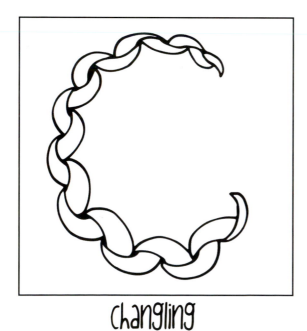

changling

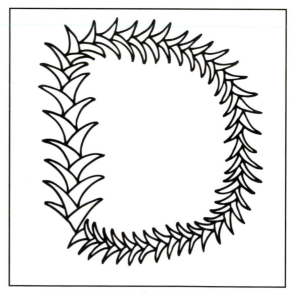

Dooleedo

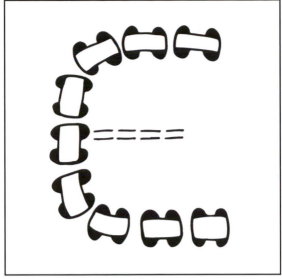

Eyelet

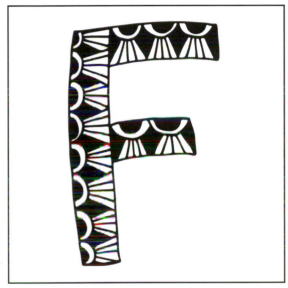

Footlight

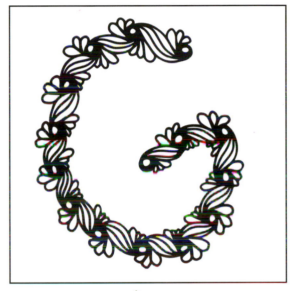

Girlande

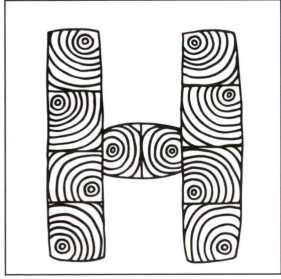

Hypnotic

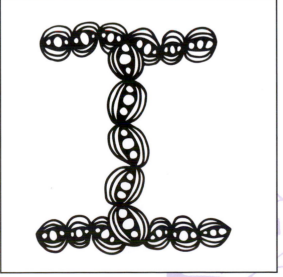

Inapod

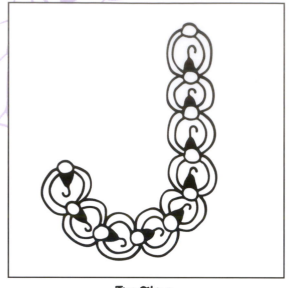

Jingles

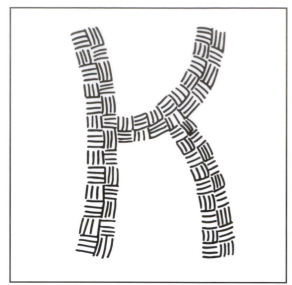

Keeko

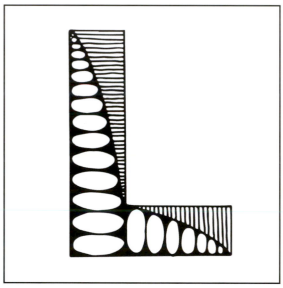

Lokomotive

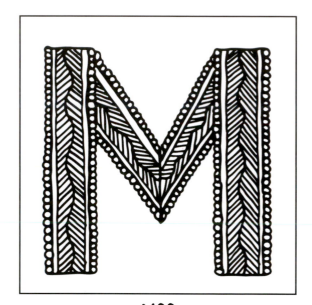

Meer

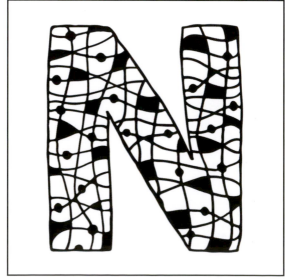

Neuron

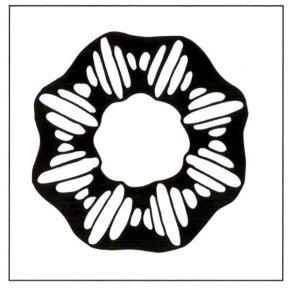

Orbs-la-dee

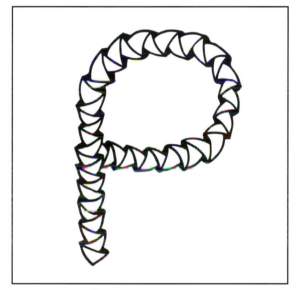

Pots-n-pans

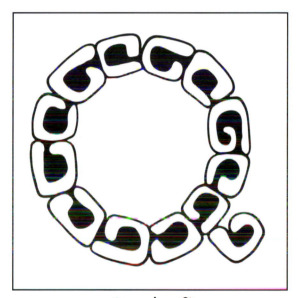

Qian-long

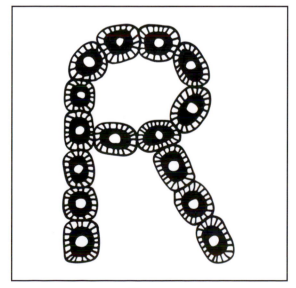

Reye

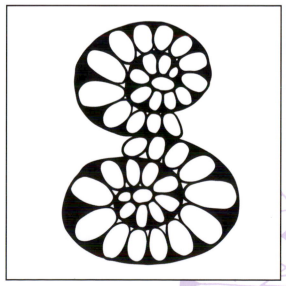

Snaylz Trayl

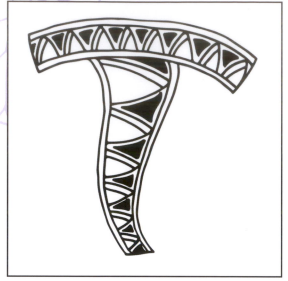

Tropicana

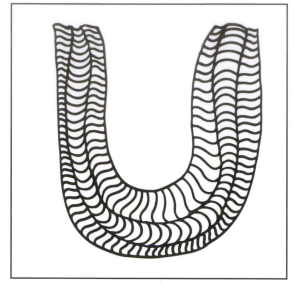

underling

Viaduct

Wired

X

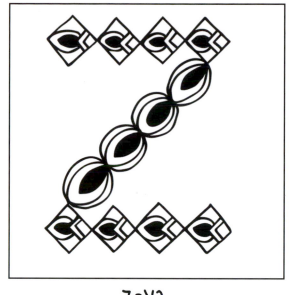

yoga

zoya

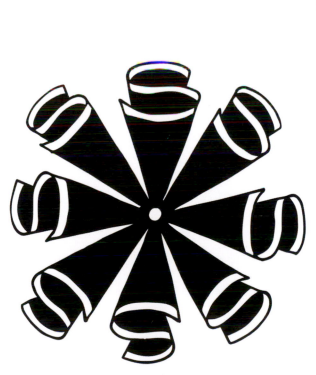

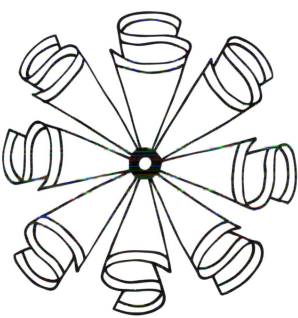

Illuminated Letters

You can also use tangling patterns to decorate introductory letters, seals, and initials.

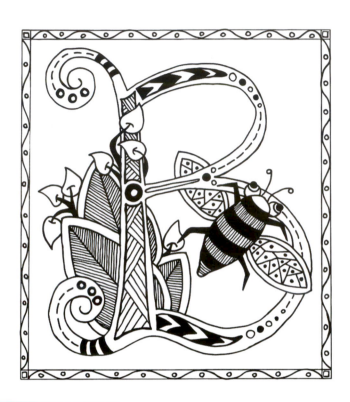

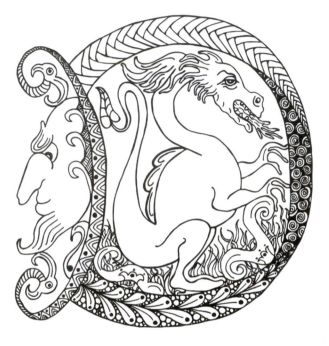

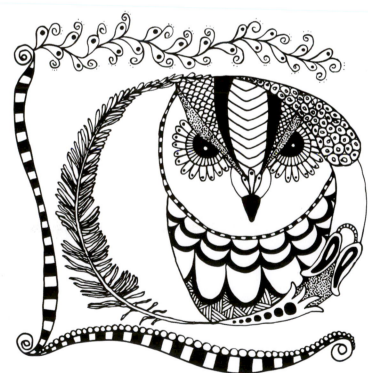

zinger Pattern

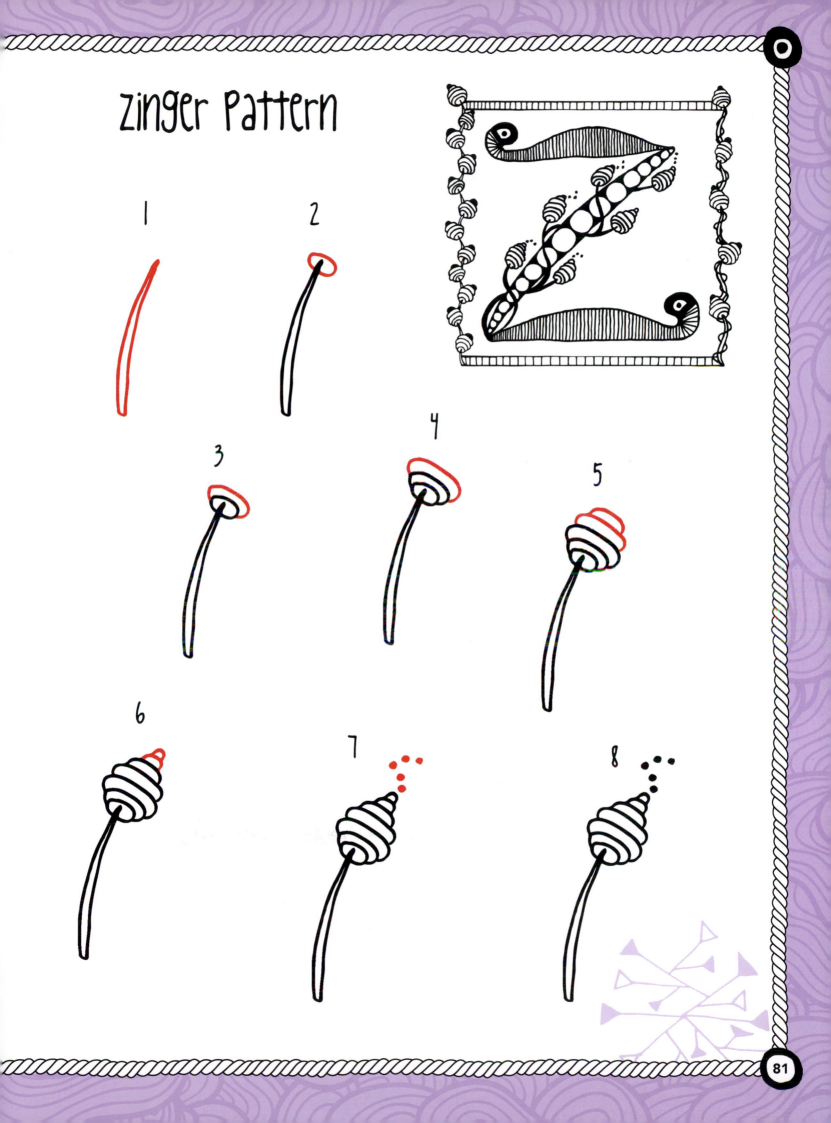

1

2

3

4

5

6

7

8

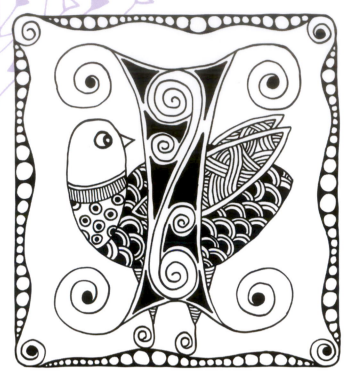

Ibex Pattern

1

2

3

4

5

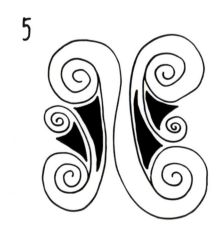

Purk Pattern

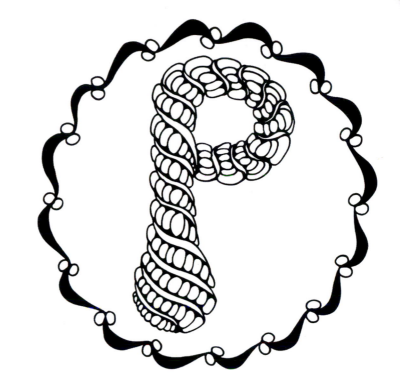

1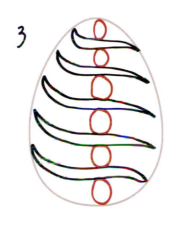

2

3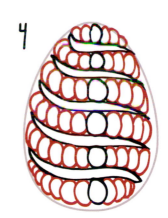

4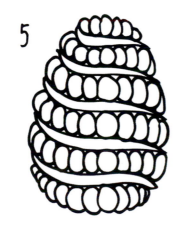

5

6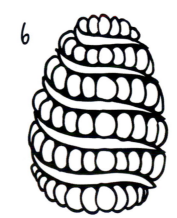

Stacked Numbers

Drawing totem poles is fun! Copy or scan the totem pole templates on page 115, and fill them in with some of the patterns you've learned. You can also stack drawings of some of your favorite things, such as numbers, hearts, stars, etc.

1

2

3

4

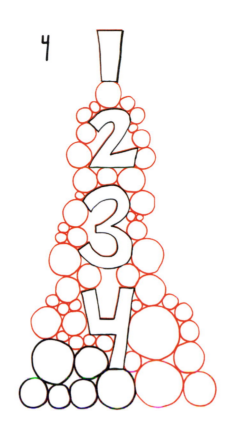

5

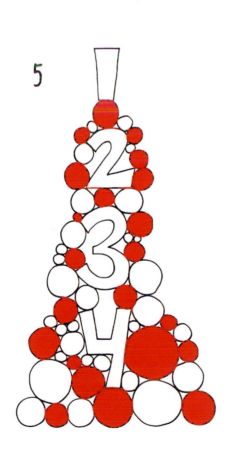

6

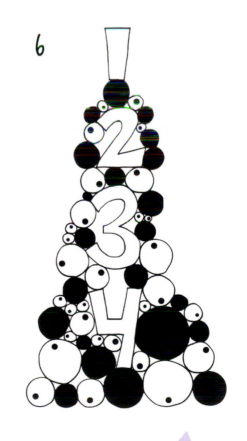

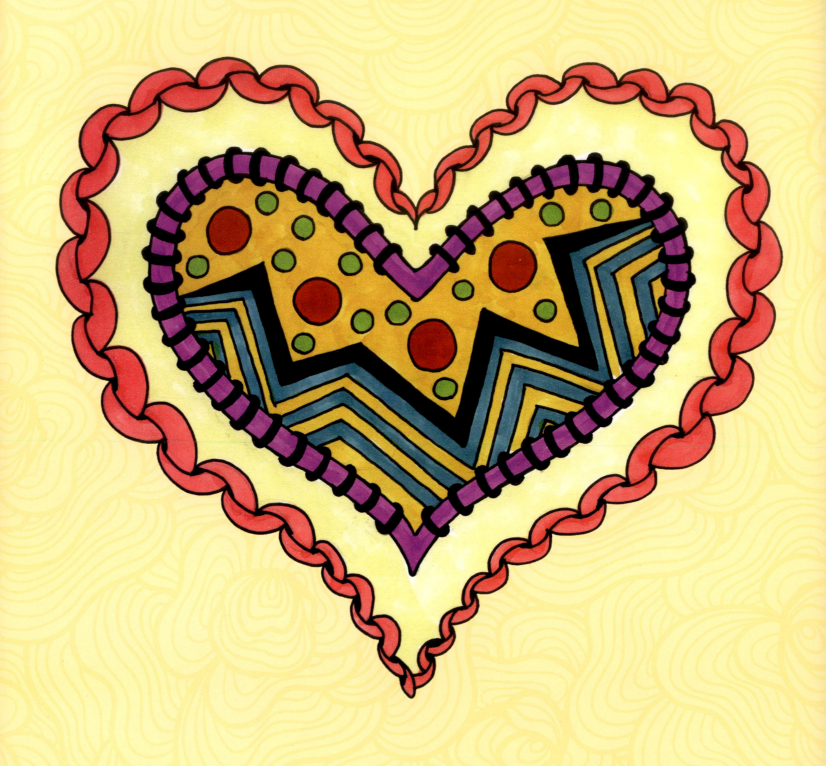

CHAPTER 4:
Tangled Up in Fun

Tangling is often used for relaxation, but it can also be fun and colorful! Learn how to create tangled embellishments for anything you want to spruce up and make your own.

MONSTER FACTORY

Welcome to the monster factory! Mix and match the monster body parts on the next few pages to create weird, wacky creatures. Copy the doodle templates on page 116, and add some of your favorite monster features.

Eyeballs

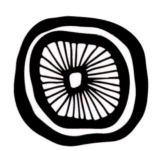

Arms

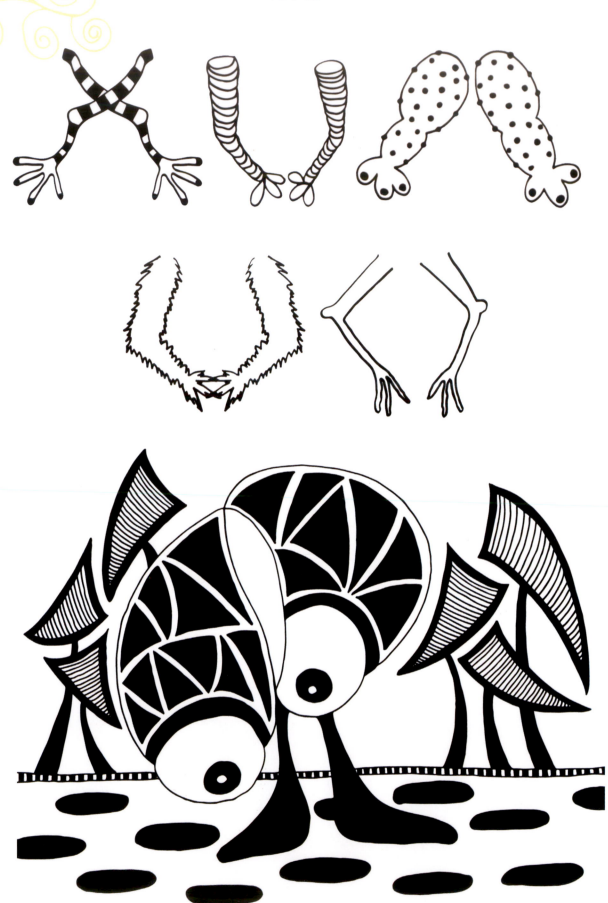

Legs

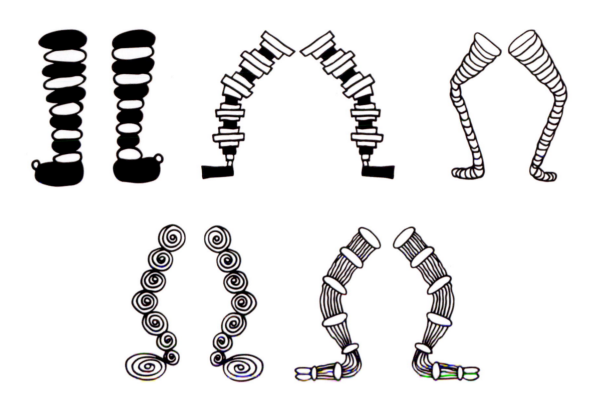

Horns and Tentacles

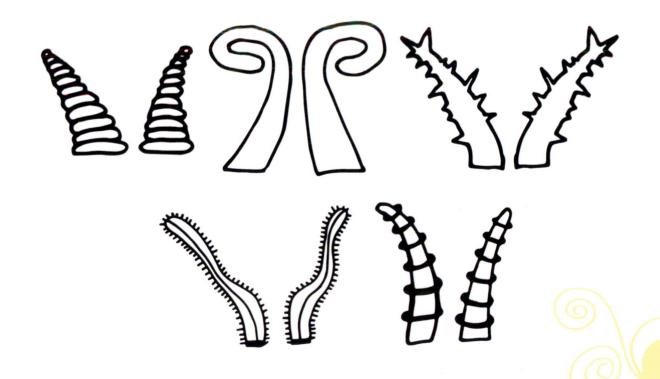

Doodled Monster

Follow the steps below to create a doodly, tangly monster! The first step is just a random doodled shape. Try drawing random shapes, and create your own unique creature!

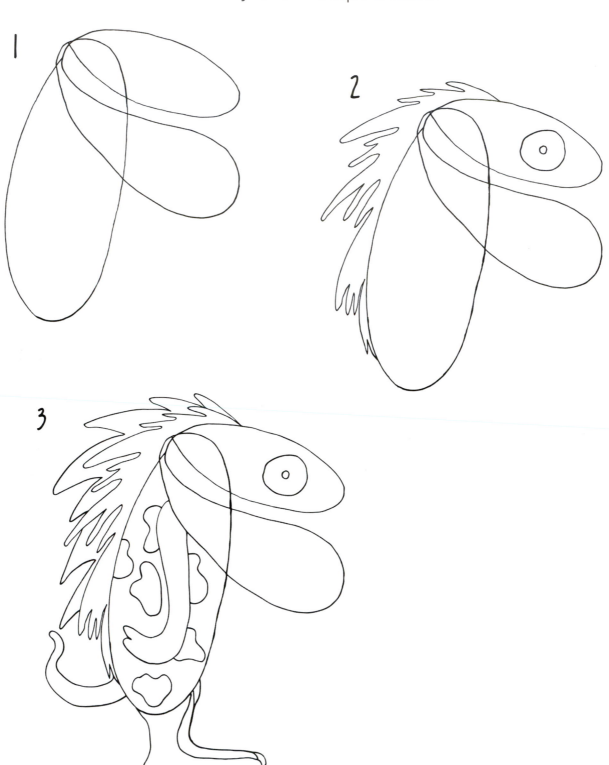

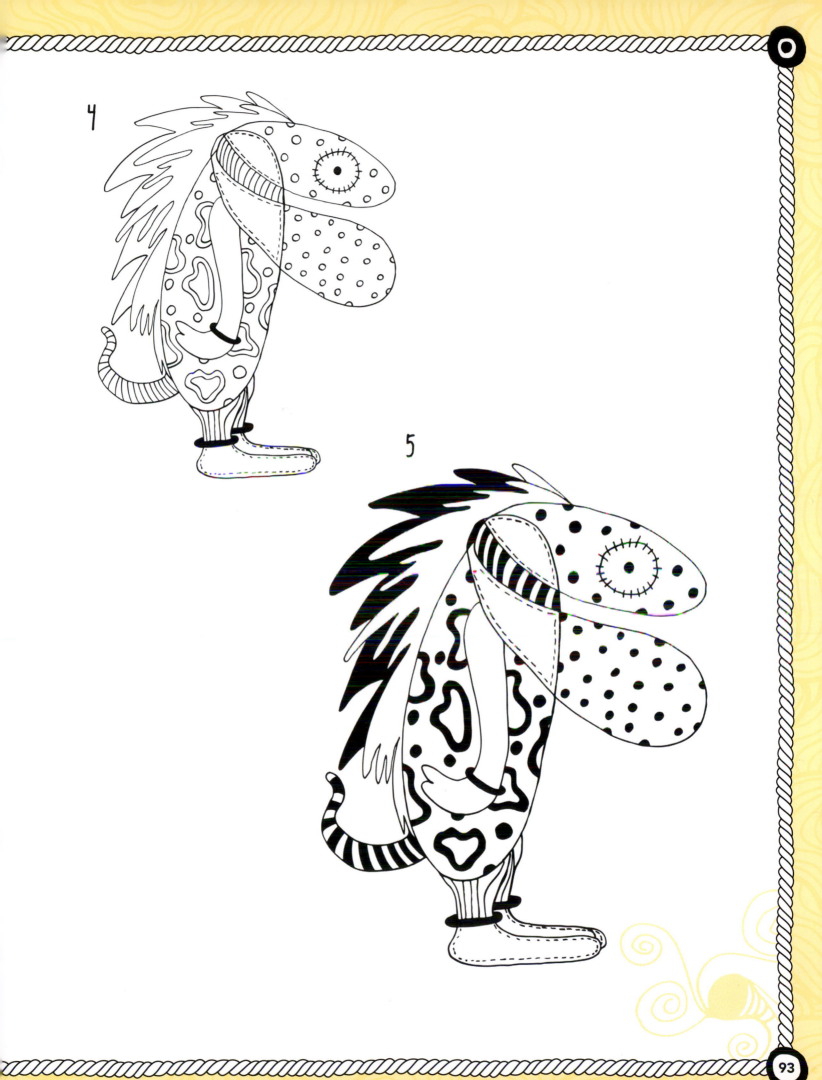

4

5

colorful tangles

Create colorful tangled hearts to decorate your room, binders and notebooks, cards, etc. They are super easy and look really cute! See the hearts below and on the following pages for inspiration, and copy or scan the heart template on page 117.

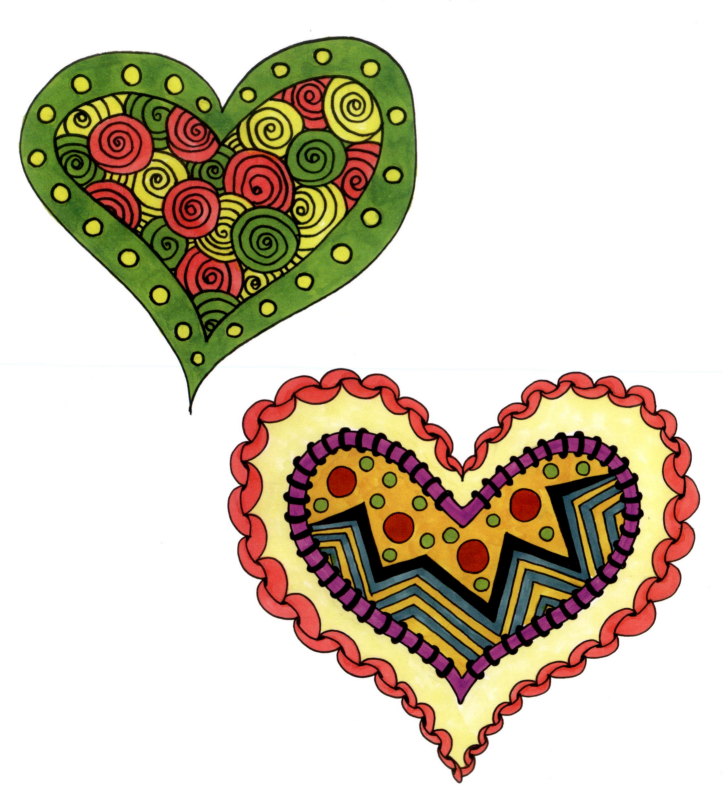

colored Pencil Hearts

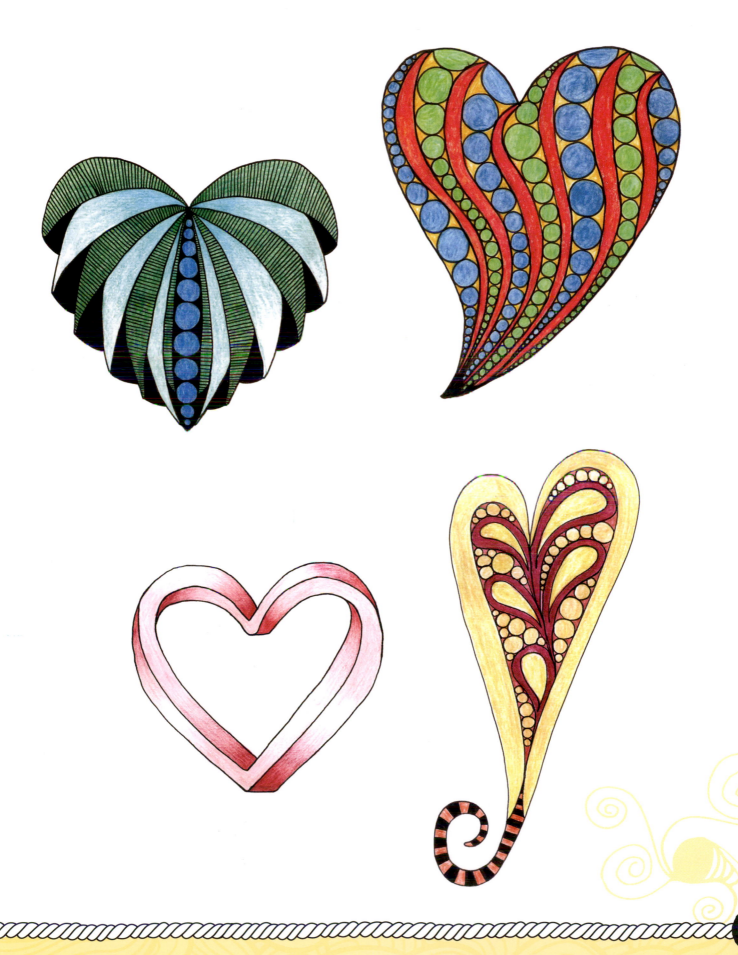

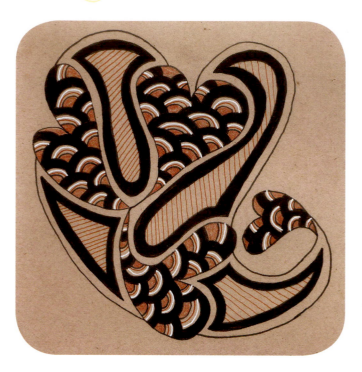

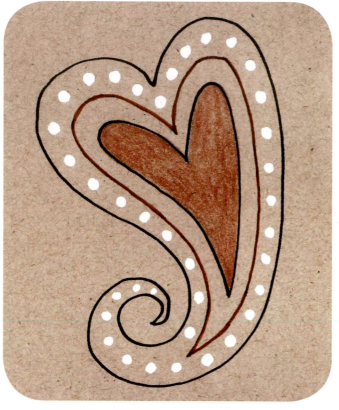

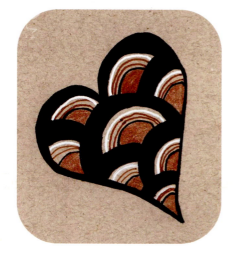

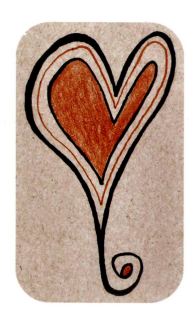

Gel Pen Hearts

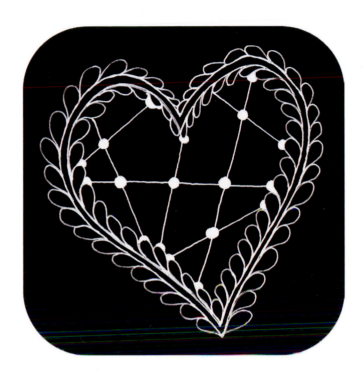

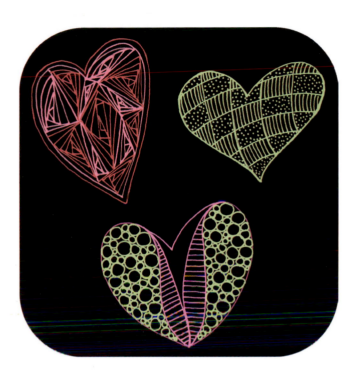

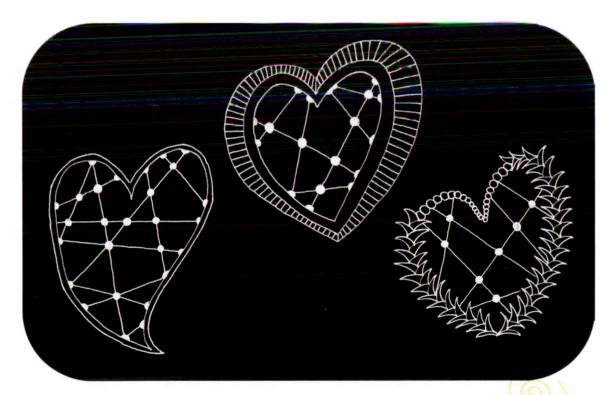

Tangly "Tattoo" Art

Create fun temporary tattoos to share with your friends! You can scan your designs and print them on special temporary tattoo paper.

1

2

3

4

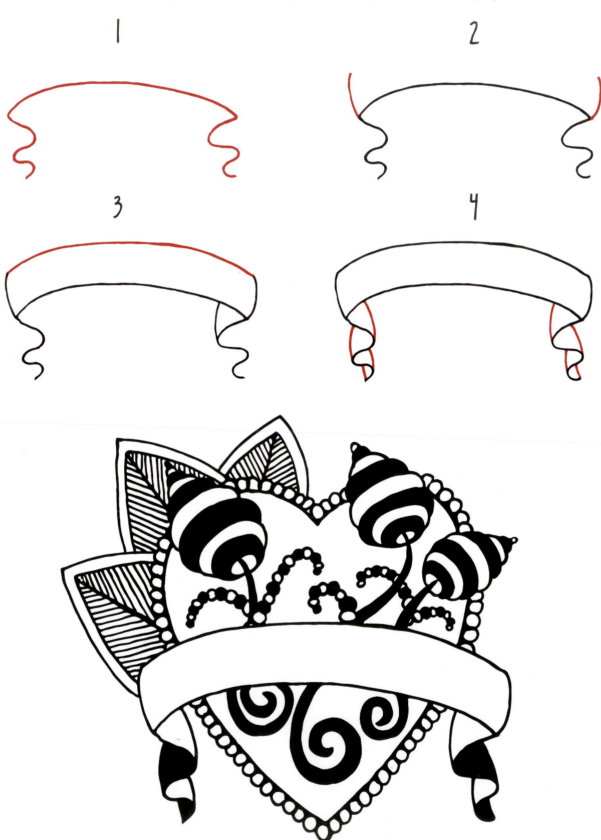

1 2

3 4

5 6

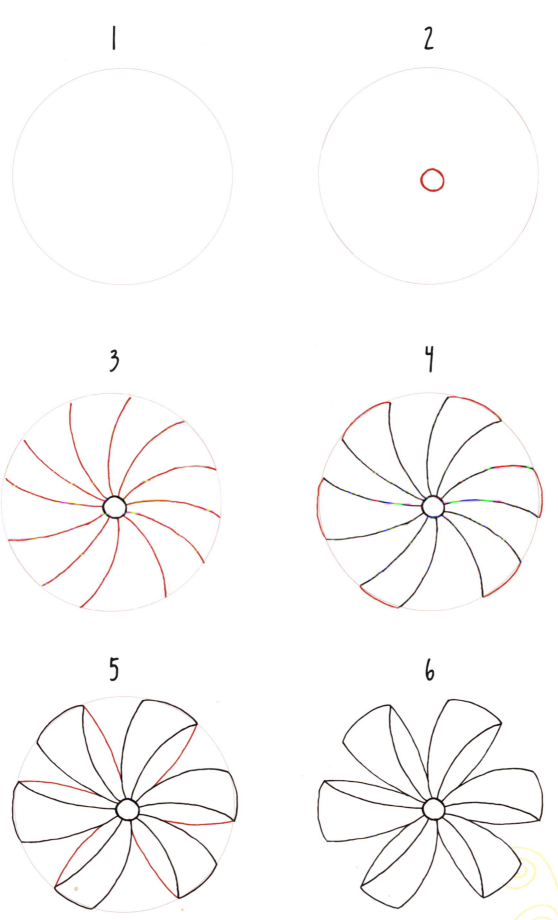

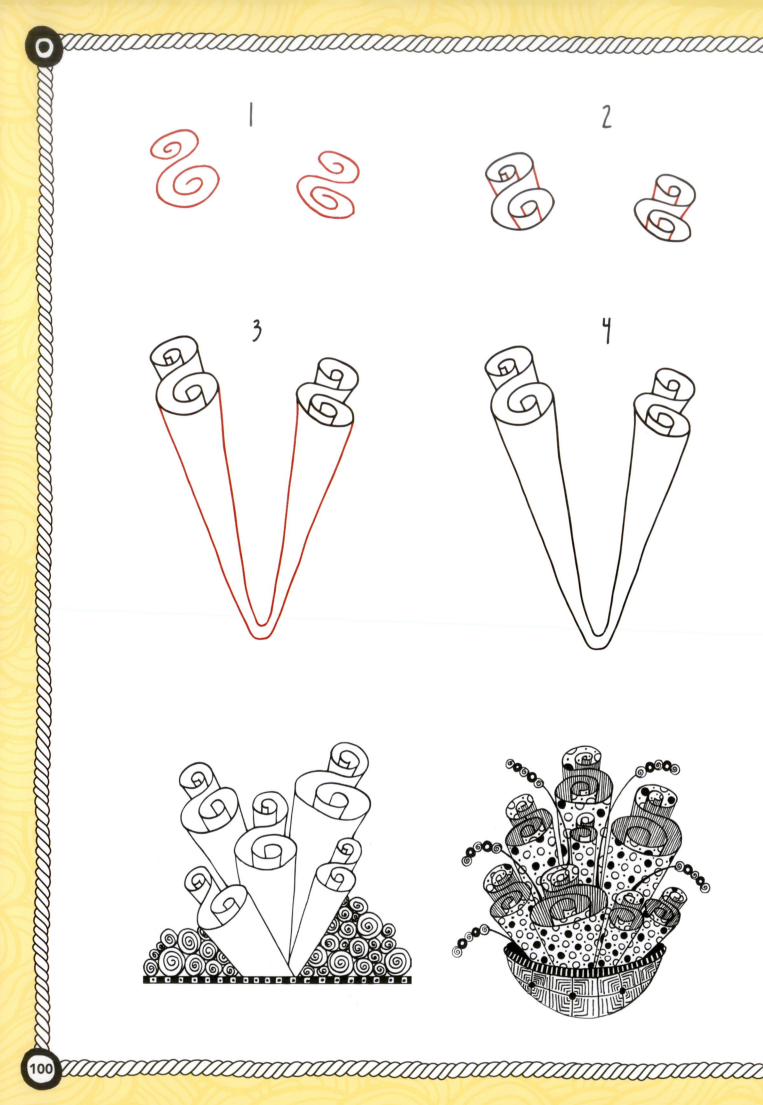

1

2

3

4

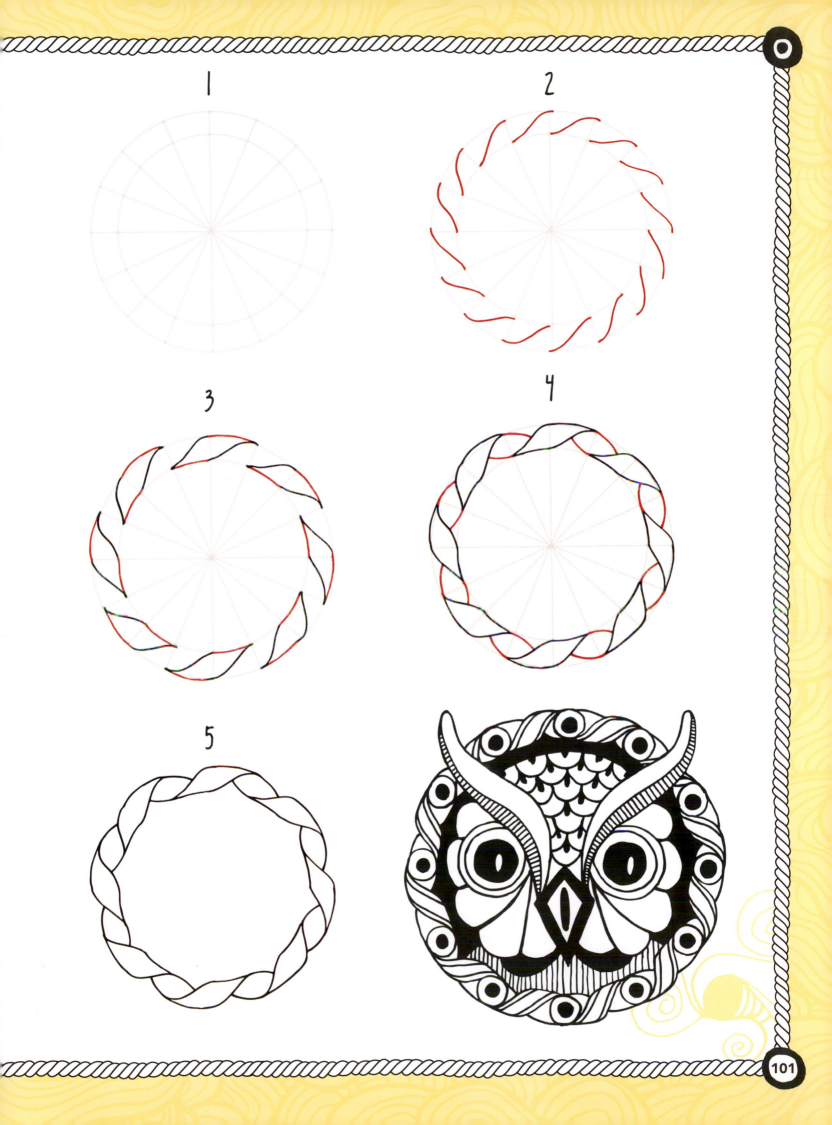

1

2

3

4

5

cadent pattern

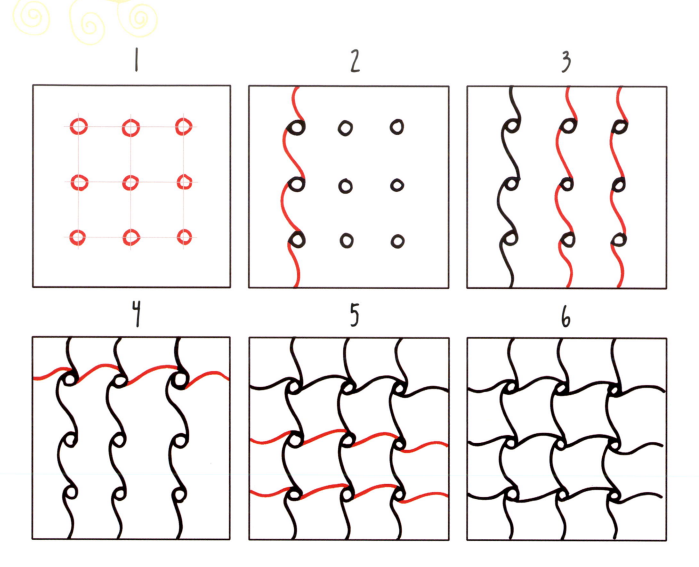

1

2

3

4

5

6

cadent variations

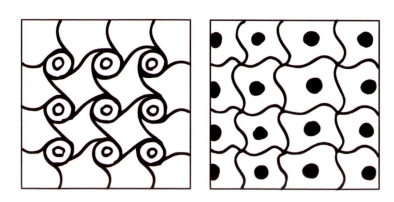

Baton pattern

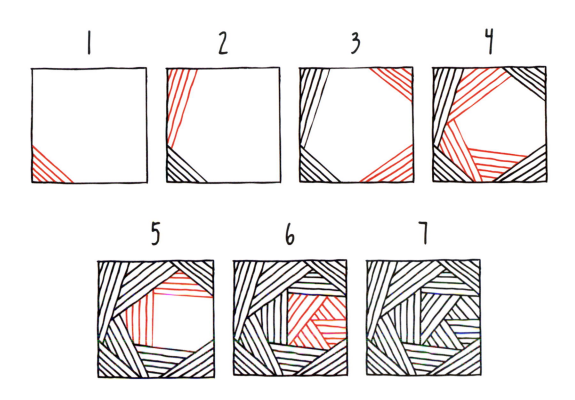

Ornamato pattern

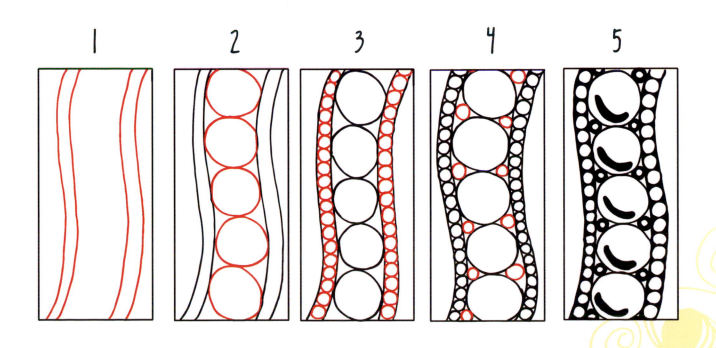

Tangled Origami

Create tangled origami! Copy or scan the templates on pages 118–119.
Use the patterns you've learned to decorate your origami.
Then cut and fold to create fun projects like the ones below.

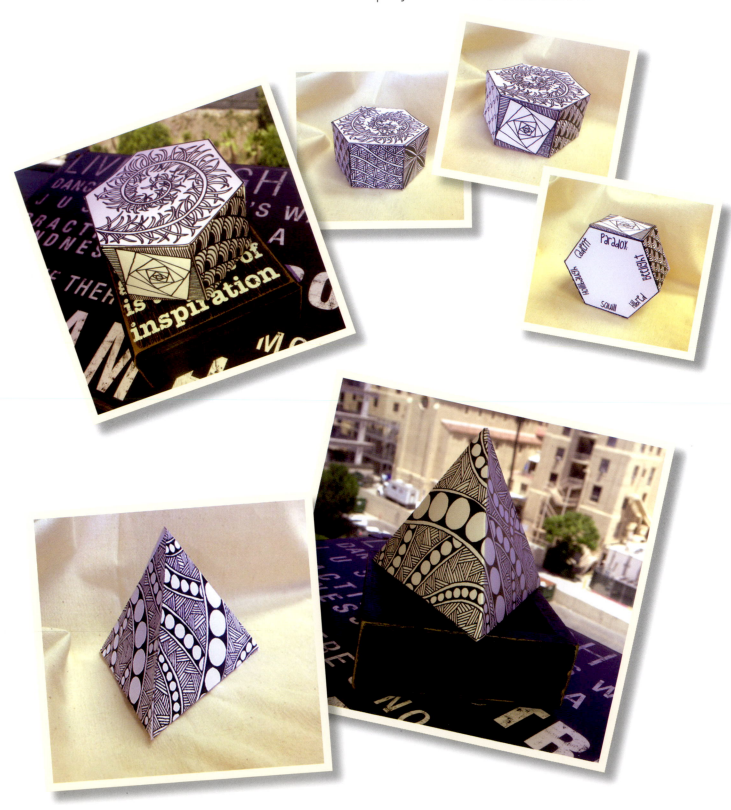

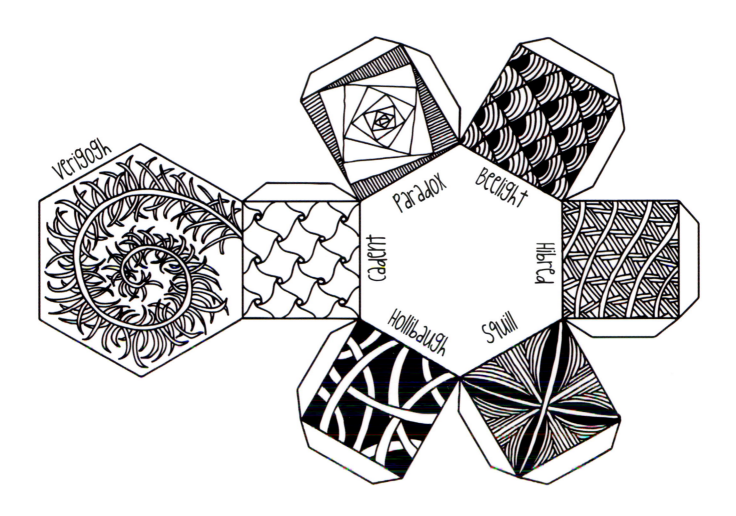

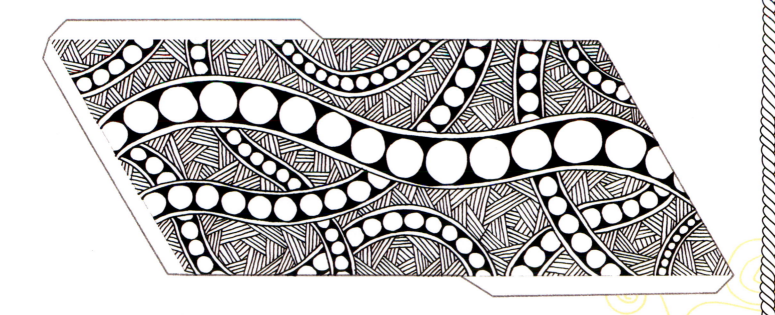

⚬⚬⚬⚬⚬⚬⚬⚬ cookie cutter tangles ⚬⚬⚬⚬⚬⚬⚬⚬

Cookie cutters are great for creating cute, tangled art. Use any that you might have lying around the house, or use the templates on pages 120–125.

STEP 1 Find a cookie cutter you like.

STEP 2 Draw around it.

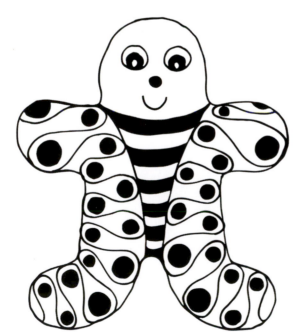

STEP 3 Add tangles! See how easy it is?

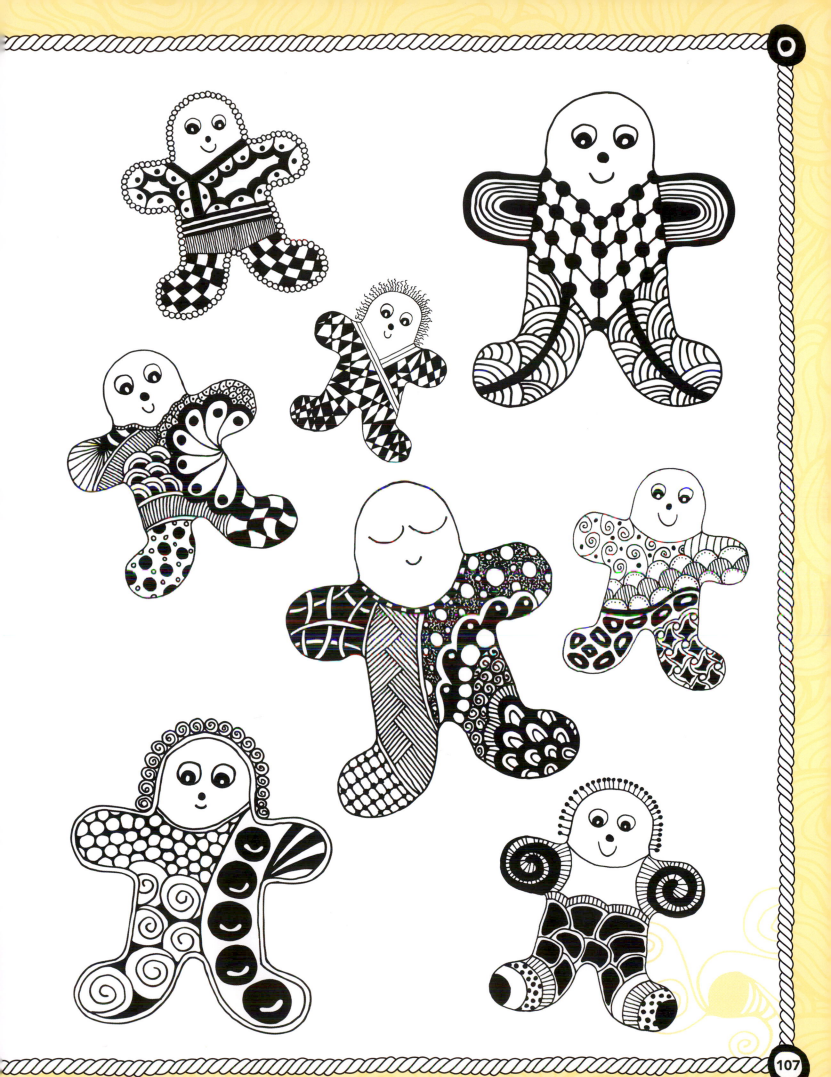

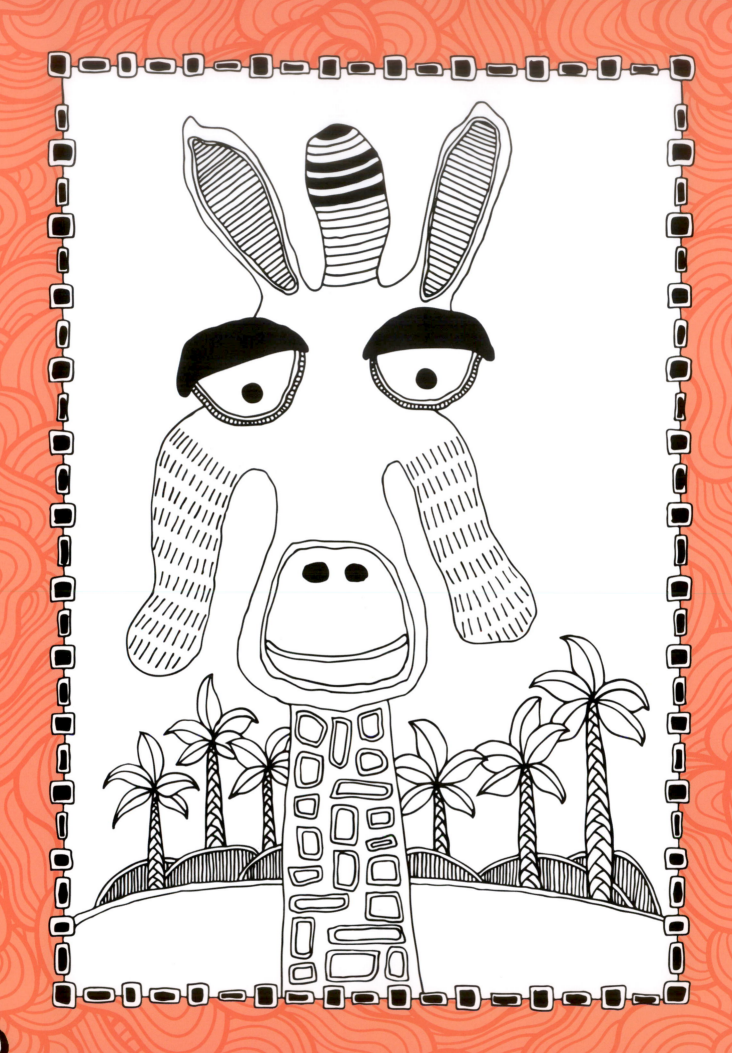

CHAPTER 5:
Templates

Copy or scan the templates on the following pages. The templates on pages 110–125 pertain to projects in this book. The templates on pages 126–127 are bonus templates for some extra fun. Use your favorite patterns in this book, or create your own unique tangled designs to fill in and decorate them.

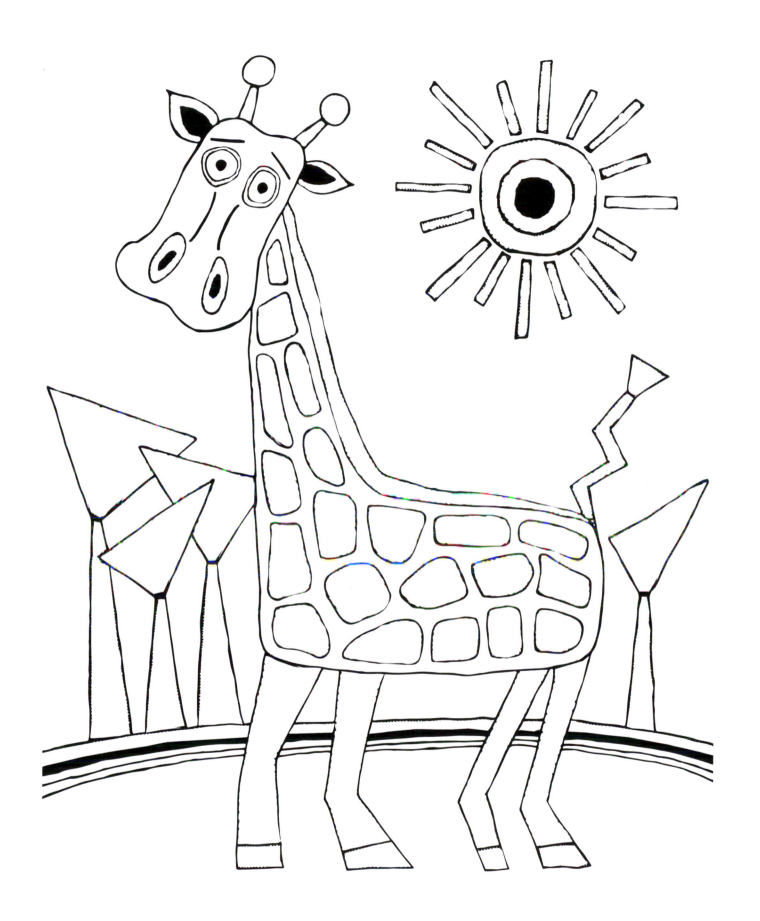

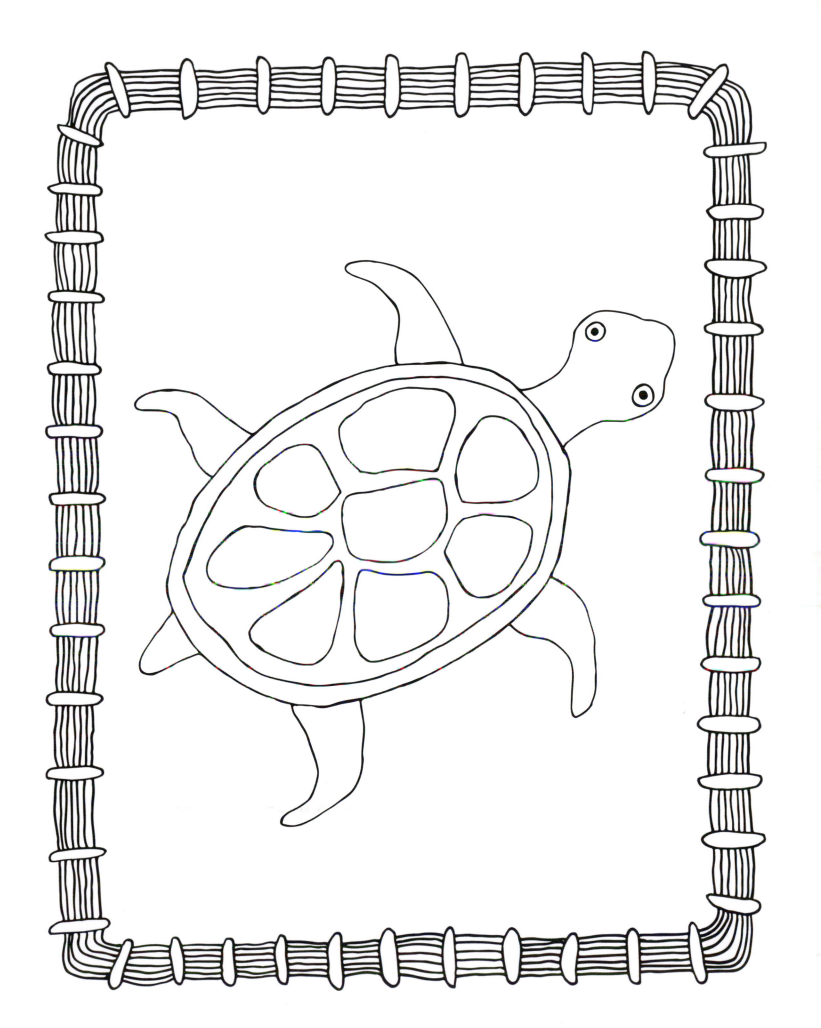

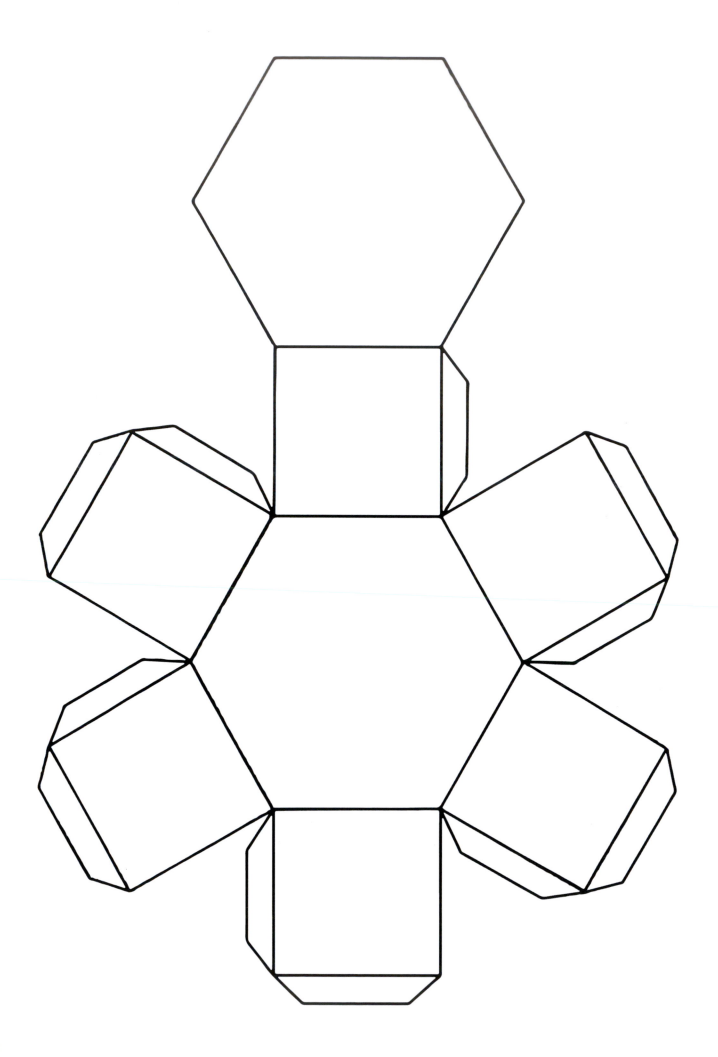

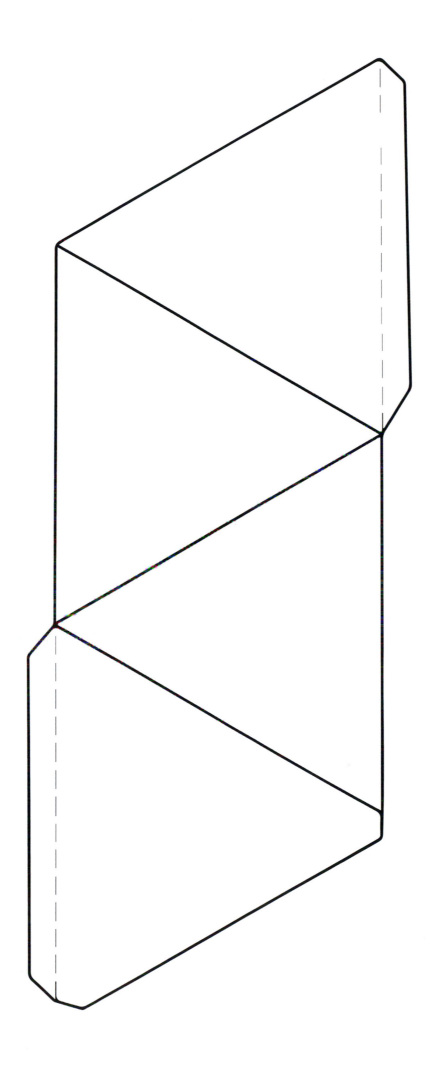

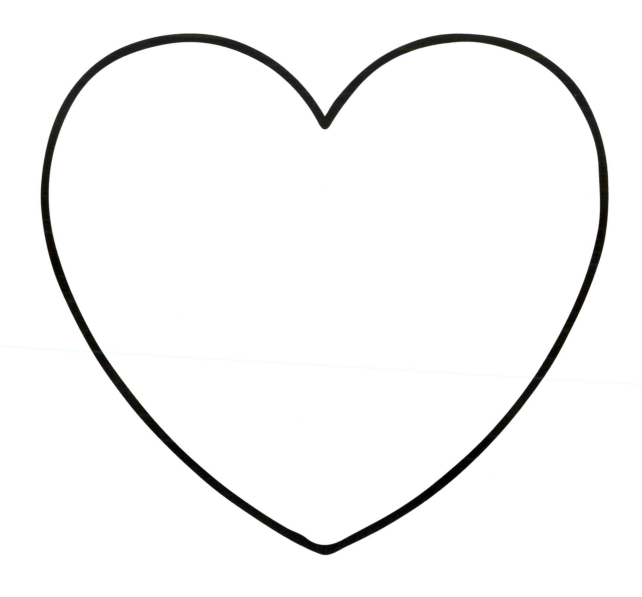

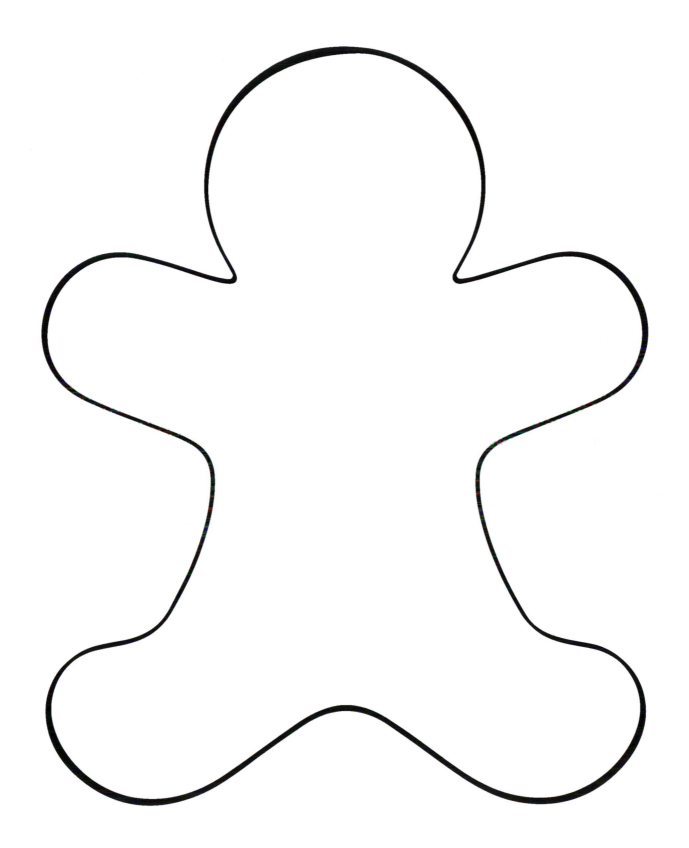

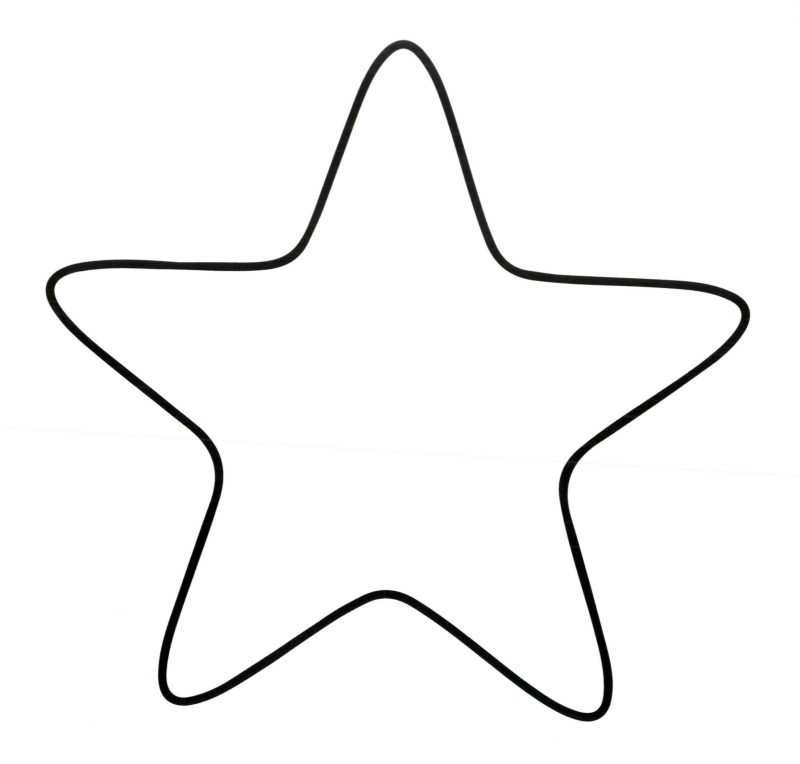

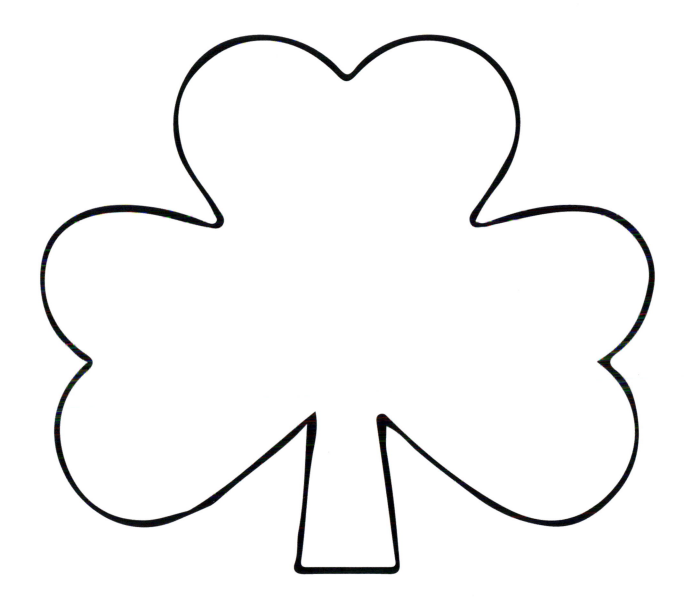

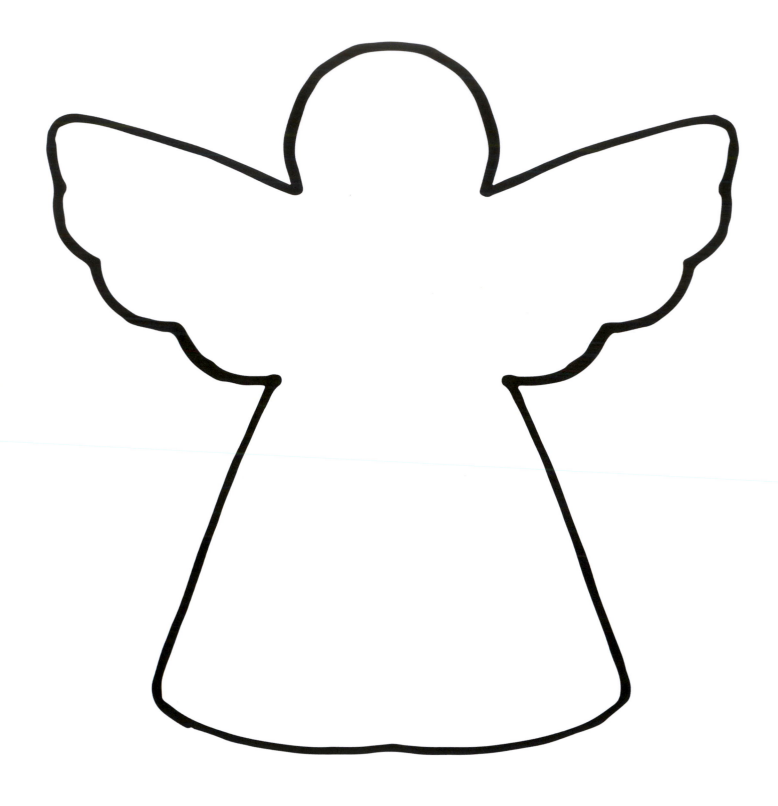

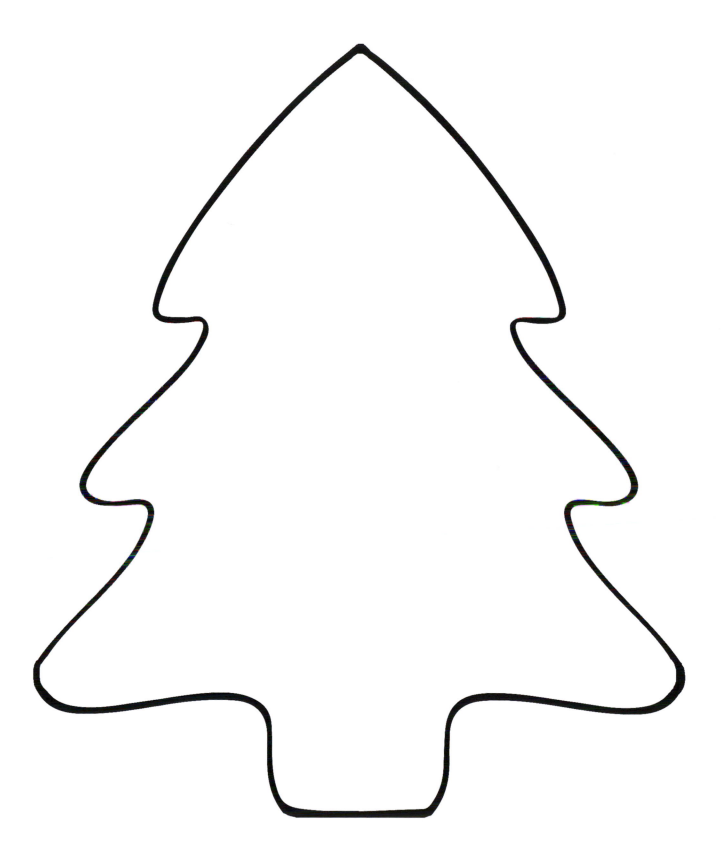

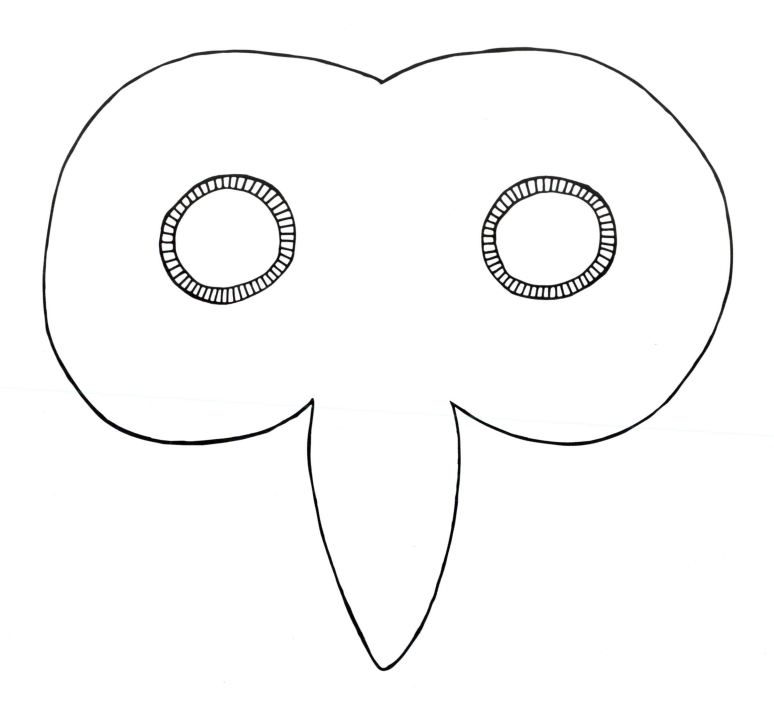

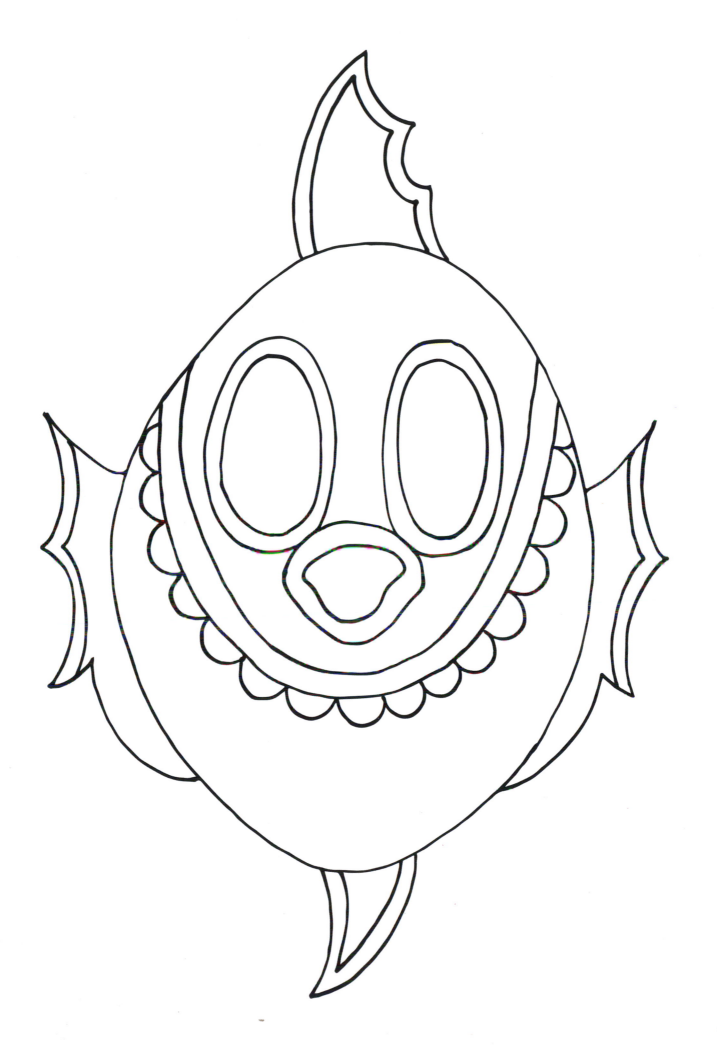

About the Artist

Talented Zentangle® artist Penny Raile is known among the art community for her whimsical designs and spirited use of color. Her downtown Los Angeles loft, with its turquoise-stained floor and hand-painted walls, reflects an eclectic mix of paintings, sewn dolls and creatures, dioramas, polymer clay objects, cardboard cuckoo clocks, and WhimBots crafted from thrift-store finds. Her drawers are full of found objects waiting to be turned into arms or legs for her newest creation. The bookcases are full of art books and journals she has filled with her own drawings and collages. Visit www.tangletangletangle.com and www.railetypepad.com to see more of Penny's work.